NOW THAT'S WHAT I CALL SHREWSBURY

David Trumper

AMBERLEY

To my wife Wendy for all her help and support

First published 2018

Amberley Publishing
The Hill, Stroud, Gloucestershire, GL5 4EP
www.amberley-books.com

Copyright © David Trumper, 2018

The right of David Trumper to be identified as the
Author of this work has been asserted in accordance
with the Copyrights, Designs and Patents Act 1988.

ISBN 978 1 4456 7376 9 (print)
ISBN 978 1 4456 7377 6 (ebook)

British Library Cataloguing in Publication Data.
A catalogue record for this book is available from the
British Library.

Origination by Amberley Publishing.
Printed in Great Britain.

CONTENTS

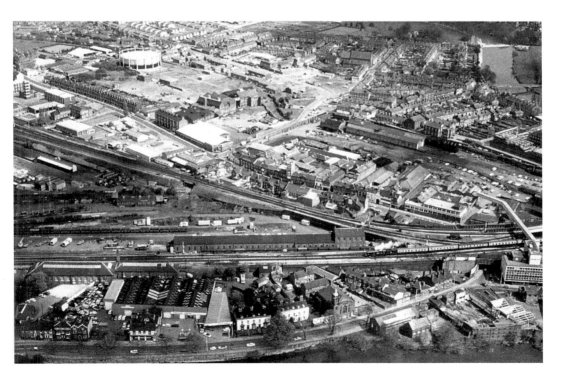

INTRODUCTION

This book covers a period of Shrewsbury's history from around 1960 to 1990 and is unique as all the photographs are in colour. Most of the views were taken by me but I'm indebted to Bob Carter, a professional photographer who worked for both the *Shrewsbury Chronicle* and *Shropshire Star*, for extra material; to Elizabeth Hector for giving me access to her late husband Anthony's collection; and to Nigel Hughes, who I first met while moving around the different sets of the film *A Christmas Carol* in 1984.

Throughout this time span Shrewsbury lost many of its historic buildings, which included three of the town's major hotels – The Raven, The George and The Crown – which were replaced with modern blocks of concrete and glass. The demolition of the Victorian Market Hall in the early 1960s was also a great loss. In black-and-white photographs it often appears dark and dingy but in colour photographs its architecture – with its rounded windows and doors, tall central tower, red, white and black bricks with Grinshill stone dressing – looks vibrant. The Shirehall in The Square was also a loss. Built entirely out of Grinshill stone, when cleaned up it would have fitted in much better with the Elizabethan Market Hall, which is built out of the same material.

With the removal of the cattle market from the centre of the town in 1959 the whole area was redeveloped. The first building on the site was Telephone House, which fronted Smithfield Road; but it proved to be dangerous, actually swaying in strong winds, and was removed in 2002. Later a riverside shopping mall was erected along with a nightclub, multistorey car park and bus station. A new road that led from Smithfield Road into Roushill and round the back of the new centre to the junction of Smithfield Road and Meadow Place was put in to open up the derelict land at the rear of Pride Hill and Castle Street. This land was redeveloped during the 1980s into two big shopping centres by Hardanger, who opened the Pride Hill Centre in 1988, and Laing, who opened the larger Darwin Centre the following year.

Several new road schemes were also developed, which helped ease the flow of traffic and opened up more derelict land. The first of these was the Column/Meole Brace Link Road that was opened in 1977. The short section leading from the Column to the Reabrook roundabout has been named Haycock Way and the section from the roundabout to Meole is called Pritchard Way leading to the A5112. Both Haycock and Pritchard were architects and builders in the late eighteenth/early nineteenth century. In 1988 a new road from the Telford Way to the Reabrook roundabout was constructed. It was named Robertson Way after Henry Robertson who came to the town in the middle

of the nineteenth century as chief engineer for the Shrewsbury to Birmingham Railway. The following year work on the gyratory system was started in Abbey Foregate and a new road leading from there to the Reabrook Island opened up the derelict Railway Sheds area. It was called Bage Way after Charles Bage, another engineer and industrialist.

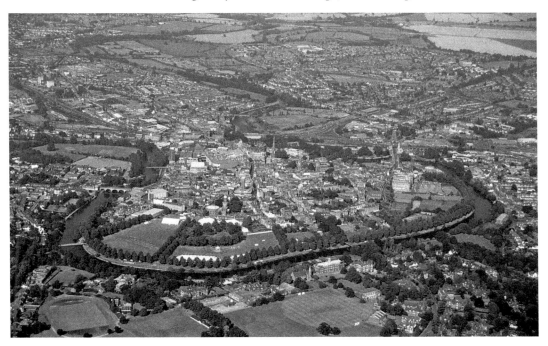

Describing Shrewsbury, the poet A. E. Housman wrote, 'High the vanes of Shrewsbury gleam. Islanded in Severn Stream; The bridges from the steepled crest, Cross the water east and west.' This aerial photograph shows exactly what he saw: the centre of the town completely surrounded by the Severn except for a gap of around 300 yards between the two arms of the river in the north. At the bottom of the photograph is Shrewsbury School and Kingsland. Moving clockwise we have Frankwell and Mountfields. Across the river lie Coton Hill, Castle Foregate and Castlefields. Crossing the river again we come to Monkmoor and Abbey Foregate and round to the right into Coleham. The suburbs stretch out to Harlescott and Battlefield in the top left-hand corner.

THE TOWN CENTRE

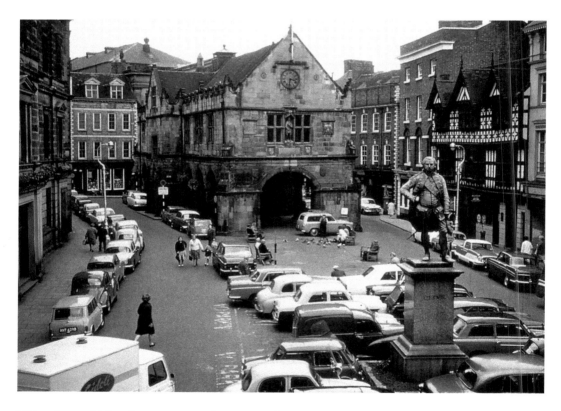

This view of The Square was taken around 1965. It was first paved over between 1272 and 1275, eleven years after the market moved there from St Alkmund's Square. The old Market Hall was built by the Corporation in 1596. The statue between the windows represents Richard Duke of York, the father of Richard III. On the left is the Shirehall that was opened in 1837 and demolished in 1971. Up until 1952 The Square had been used as a bus station until it was moved to Barker Street. The area was then used for parking until the right-hand section was paved over in the 1980s and the whole space finally pedestrianised in 1996.

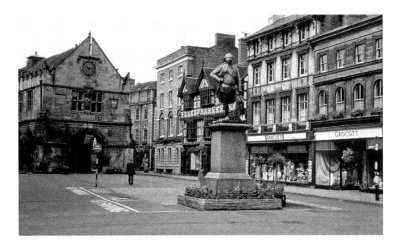

This photo was taken on a Sunday around 1960 when all the shops were closed. On the right is Grocott's Ladies' shop, which was known as the 'Fashion Centre of the West Midlands'. It was founded around 1860 by Redmayne & Co., who also had shops in London and Harrogate. The statue of Clive of India was unveiled on 18 January 1860. It stands around 9 feet high and was executed by Baron Marochetti in bronze, from a portrait by Nathaniel Dance. The timber-framed building behind is the Plough Inn. The top storey was added at the beginning of the nineteenth century by a Mr Price, who copied the traditional style of Shrewsbury architecture.

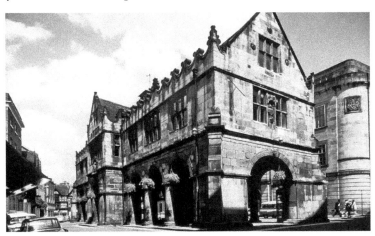

This is a view to the rear of the old Market Hall. Note the sundial on the corner of the building and the statue of an angel between the windows. The angel holds a shield bearing the arms of England and France and was rescued when one of the town's old gateways was demolished on Castle Gates. The building to the right is an extension to the Shirehall that was built towards the end of the 1930s and formally opened in 1940. At the top is the coat of arms of Shropshire and below a war memorial, which bears the inscription, 'This stone was inscribed in honour of those members of the County Council staff who laid down their lives in the service of their Country 1914–1918, 1939–1945.'

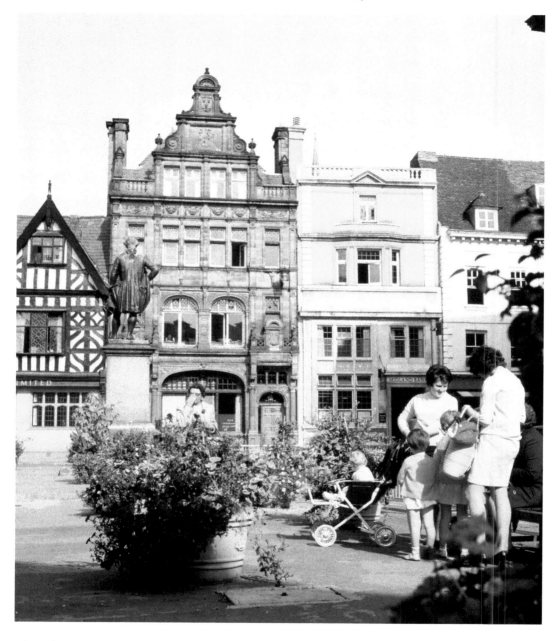

The photographer is looking across The Square to the High Street in around 1970. The central area has been cleared of cars and furnished with benches and flowers for the benefit of tourists and shoppers. The timber-framed building is Cartwright's Mansion, built in 1598 and occupied by Martins Bank. The tall building was built in the Flemish style for the Alliance Assurance Co. in 1891. They later merged with the Sun Insurance Office to become the Sun Alliance. The building is now occupied by the Halifax Building Society. To the right is the Midland Bank, in a building bought by the North and South Wales Bank in January 1901 for £5,000.

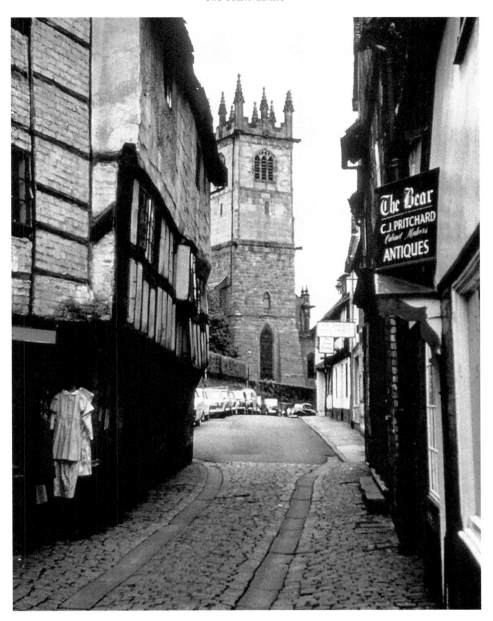

Fish Street takes its name from the fish boards that used to hang on the wall on the left between St Alkmund's and St Julian's churches. St Julian's Church dates from the tenth century, but with the exception of the tower, the main body of the church was rebuilt in the classical style in 1750. The Bear Antiques shop is housed in a building that was an inn called the Bear and recorded between 1780 and 1910. It gave its name to the buildings on the left that are known as the Bear Steps, referring to a flight of steps that go through the centre into St Alkmund's Square. By the 1960s the buildings were in a very dilapidated state and in danger of demolition, but were saved by the newly formed Civic Society, who now have their offices there.

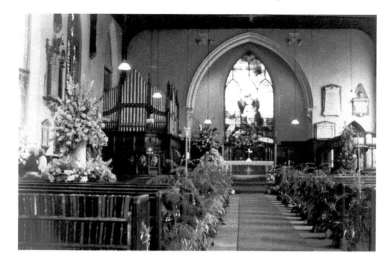

With the exception of the tower and spire the Church of St Alkmund was completely rebuilt in 1793. After the collapse of old St Chad's the parishioners decided that their church might be unsafe, so proceeded to demolish it. It was a fine medieval structure and so well built that parts were dismantled by using gunpowder. Local stonemasons Tilley and Carline rebuilt it in a Gothic style and it was opened for worship on 8 November 1795. The magnificent east window is the work of Francis Eginton, for which he was paid £200. It represents Faith and is a copy of the Madonna from Guido Reni's *Assumption of the Virgin* in Munich.

This is the junction of Pride Hill and Butcher Row looking towards St Alkmund's Church, hidden behind the trees. Butcher Row has also been known as the Shambles and Double Butcher Row, to distinguish it from Single Butcher Row, which ran from the corner on the left to the top of Pride Hill. On the right-hand corner is The Golden Egg, a company that opened up restaurants all around the country in the mid-1960s. The interiors were made of coloured plastics and fibreglass and their meals were moderately priced. On the left is Richard's ladies' shop. The timber-framed building behind is called Greyhound Chambers, taking its name from the Greyhound Inn that stood in front of it on Pride Hill.

This view of Pride Hill looking down towards the new Market Hall was taken in the 1970s. The market clock is not central like the old one that could be seen all over the town. The road is still open to traffic: the right-hand lane leads on to Castle Street while the left-hand lane turns into St Mary's Street. The first shop on the right is H. Samuel the jewellers, who are still trading there, whereas Preedy the tobacconist, Etams ladies wear, Weaver To Wearer gent's tailors and Paige ladies' outfitters are long gone. The furniture shop on the left belonging to Dale Forty has also closed.

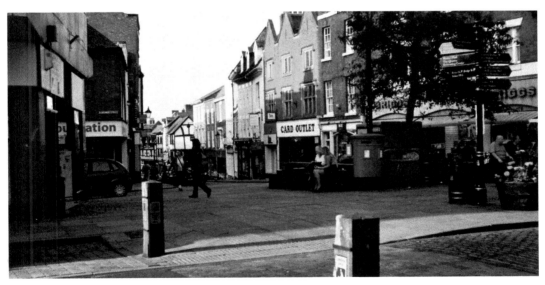

This view is looking down Mardol from Mardol Head. One explanation of the street name is from the Anglo-Saxon meaning the Devil's Boundary. At one time you could drive out of Mardol and into Mardol Head or Shoplatch, but in the 1970s the road was blocked off, turning traffic into Claremont Street. A raised garden with seating was placed there, which allowed shoppers a brief rest and a place to meet friends. Unfortunately the garden was replaced in 2004 with the controversial Darwin's Gate. On the right behind the trees is Brigg's shoe shop, which was there for over a hundred years until it was converted into a French restaurant.

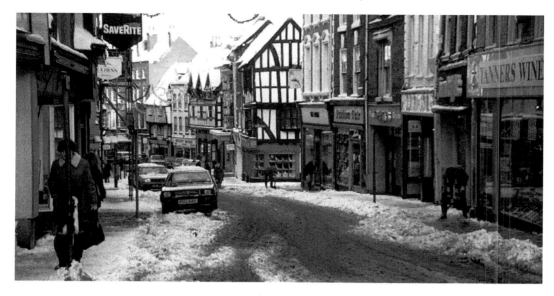

This view of Mardol was taken just after Christmas during that severe winter of 1981/82. The cold spell began during the night of 11 December when the temperature fell to –22.3 degrees Celsius, the lowest ever recorded. A heavy snowfall on 8 January also disrupted traffic in the town centre. On the right is Tanner Wine Shop, WG Cross photographic equipment, Swan's piano and organ shop, Fashion Fair clothes shop and Pets Corner. Just William Wine Bar is on the opposite corner in the timber-framed building and just beyond the illuminated red sign of the Empire Cinema. On the left is the sign for SaveRite, one of Morris's grocery outlets and A. Henn the jeweller.

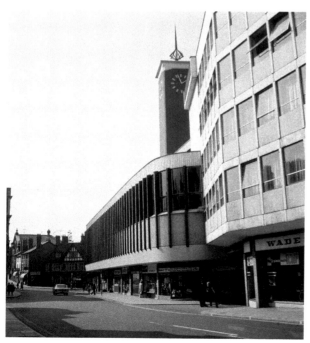

This view of Shoplatch was taken soon after the new Market Hall was completed in 1964. The name of the street is derived through several changes from the residence of the Schutte family. Wades furniture store on the right occupied two floors at the Mardol end of the market, while other shops under the building going towards Belstone included Radio Rentals, Millets, Wimpy's café and Nursery Needs. Just behind the car on the corner of St John's Hill and Belstone is the Exchange Hotel, which was first recorded in 1868 and rebuilt in the 1935. Two-way traffic was also in operation in the street at this time.

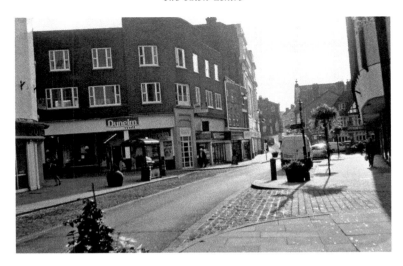

This view of Shoplatch is looking towards the junction of Market Street on the left. The building occupied by Dunelm occupies the site of the old George Hotel. The shop was first occupied by a Tesco supermarket and was opened on 21 September 1965 by Miss Silver Gill, nineteen-year-old Debbie Lee, who represented Gillette Safety Razors. The office space above was occupied by the inspectors from the Sun Alliance Insurance Group until their new office in The Square was opened. The shop has recently housed Maplins, who were electrical appliance retailers until they closed in the summer of 2018.

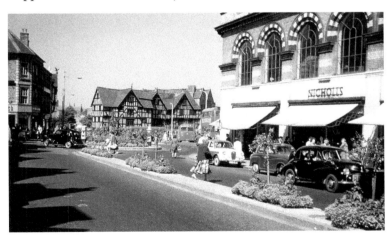

This is Belstone looking towards the Bus Station in Barker Street around 1960. Percy Thrower and his men have planted the traffic island and central reservation, enhancing Shrewsbury's reputation as the Town of Flowers. On the right is the Market Hall with its distinctive red, white and dark blue bricks and rounded windows that show it to be a more vibrant building than the grey images on the black-and-white photos. The bus station opened there in January 1952 and was an immediate success with shoppers, as it was situated next to the Market Hall. The Midland Red buses also add a splash of colour in the summer sunshine.

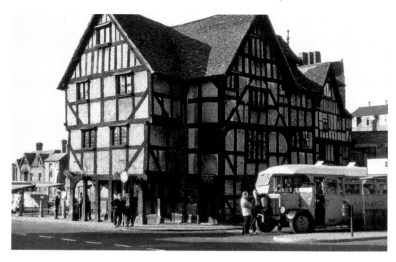

Two Midland Red employees stand in front of a bus next to the S13 stand that took passengers up as far as Copthorne Hospital. Until the demolition of property in the Barker Street, Bridge Street and Hill's Lane area in the 1930s, few people realized that Rowley's House in the background existed. It was completely surrounded by buildings that hid it from the main street. Note the inverted V just above the bus that shows the eaves of the New Ship inn that butted right up to it. The Rowley family originated from Worfield near Bridgnorth and were brewers. It is estimated that around 100 mature oak trees would have been used to construct the frame.

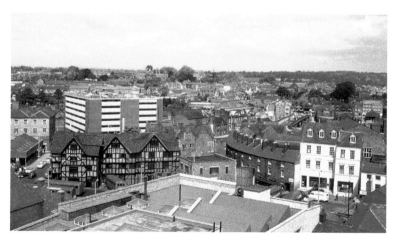

This view is taken from the roof of the new Market Hall looking towards Rowley's House and the bus station. To the right of the house is Rowley's Mansion, reputed to be the first brick-built building in the town. By 1808 it was adapted for commercial use and had become a woollen factory. It was later used as an auction house until Richard Downes, a wholesale hardware merchant, converted it into a warehouse. In 1983 it was restored and transformed into part of the Borough Museum. It is now used by the University of Shrewsbury. The multistorey car park behind Rowley's House was opened in August 1963 and was demolished in August 2002.

This is Hill's Lane looking towards the bus station and canteen. On the right is Rowley's Mansion just after Downes's warehouse had closed. The flat-roofed building to the left was also part of the warehouse but was demolished during the mansion's conversion into a museum. The double doors below the sold sign on the left were the entrance into Singleton & Cole's. The firm were tobacco, cigarette and cigar manufacturers who later branched out into a wholesale goods company. The pub to the left was the Green Dragon, first recorded in 1868. It was a popular venue as it was a free house selling Bass and Worthington's beers until it closed in the 1970s. Both properties were converted into part of the Victorian Arcade.

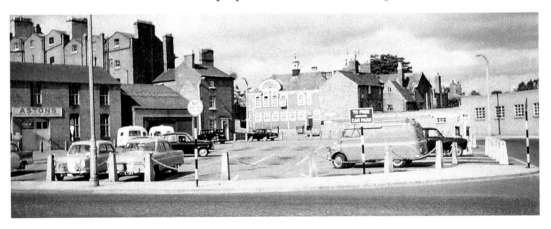

This is a view across Bridge Street and Lower Claremont Bank towards the Priory Grammar School. The school was opened in 1911 for boys and girls, although both were strictly segregated. It became a boys' grammar school when the girls moved to new premises on Longden Road in 1939. It became Shrewsbury Sixth Form in the 1980s. On the right is the newly built garage complex where Morris's kept and maintained their fleet of delivery vans. Its site is now occupied by Montgomery's Tower, another JD Wetherspoon establishment. Top left is the rear of the buildings on Claremont Bank and below is the furniture warehouse belonging to Astons, whose main store was in Shoplatch. Soon after this photo was taken a multistorey car park was erected in the open space.

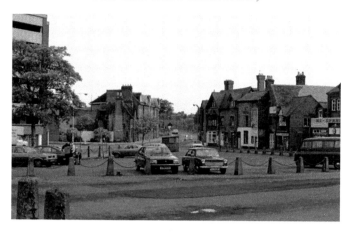

The photographer is looking towards the Welsh Bridge with Bridge Street on the left and Hill's Lane on the right. Behind the tree on the left is the multistorey car park at the junction of Lower Claremont Bank. Hill's Lane was once known as Knockin Street, derived from a medieval word meaning shaped like a cucumber, which describes the line of the street. The modern name commemorates John Hill, who married into the Rowley family and lived in the mansion. Just to the left of Hi-Speed Tyres is Carnarvon Lane, a narrow passage linking Hill's Lane to Mardol. It was named after Ludovick Carnarvon who lived there around 1460.

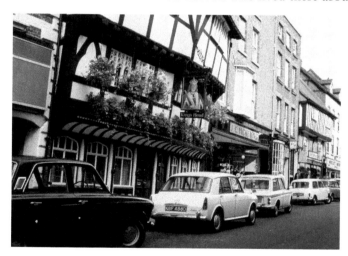

The King's Head in Mardol is one of the most attractive inns in the town and the building has been accurately dated to 1404. It was originally known as the Last Inn but changed to its present name around 1804. When the inn was refurbished in 1987 the builders discovered a wall painting depicting the Annunciation and the Last Supper that are thought to date from the early fifteenth century. Mr Pickering opened his shop just to the right in 1913, selling and repairing motorcycles and bikes. During the second half of the twentieth century the business moved away from motorised machines to concentrate on bicycles, their accessories and toys. The shop was moved across the road and finally stopped trading in December 2002.

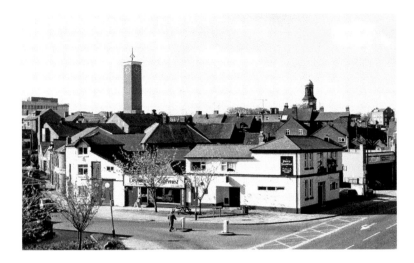

This view was taken from Frankwell footbridge. The inn on the corner of Smithfield Road and Roushill is the Salopian Bar. It was first recorded as the Globe. Due to the close proximity of the cattle market it changed its name in 1916 to the Smithfield. When the cattle market moved to Harlescott it became known as the Proud Salopian, named in honour of Thomas Southam, mayor of Shrewsbury on three occasions and owner of a large brewery in Chester Street. After being refurbished in 2004 it became known as the Soho, but had changed to the Salopian Bar by 2009. Two doors to the left is Birch's hardware store, an Aladdin's cave of useful articles.

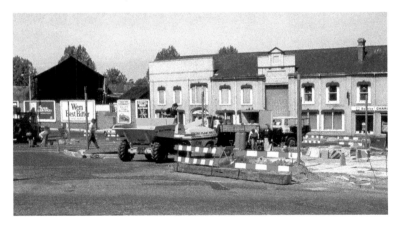

This is the junction of Smithfield Road and Chester Street, which has been realigned several times over the years, the most recent in 2013. The buildings on the right were once occupied by William Howe, an ironmonger who sold a great deal of agricultural hardware. In 1945 the site was acquired by Charles Clarke Ltd and renamed Austin House after the cars they sold. As well as a car showroom there was a garage and repair shop and for a number of years the firm sold petrol, distributed from roadside pumps in Chester Street. The firm also had a garage and showroom in Roushill. After the firm closed these buildings were demolished and new town houses were built on the site. Behind the hoardings on the left are Woppy Phillip's premises.

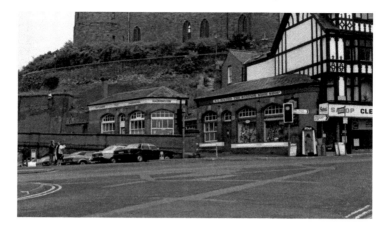

This is the junction of Chester Street with Castle Foregate to the left and Castle Gates to the right. The couple talking are standing in the railway station forecourt. The forecourt was lowered at the turn of the twentieth century. The shop on the left was a gents barbers, for many years occupied by R. D. Kinnersley and then by Tony. G. H. Brookes was a former owner of the Station Shoe Shop and the small building between the two shops was a shoe repair shop. The Salop Cleaners in the timber-framed building was once occupied by one of Morris's cafes and confectionary shops. The lady outside the Star cabin is Vera, who sold evening papers on that corner, in all weathers, for many years.

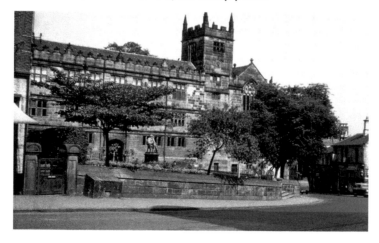

The next three photographs show the changes to Shrewsbury Library between 1965 and 1984. The buildings were originally built to house Shrewsbury School, which was founded by Edward VI in 1552. By the end of the 1870s the site was deemed unfit, so in July 1882 the school moved out of the town centre to a new site on Kingsland. This building was then purchased by the council, who converted the ground floor into a library, while the top room to the right of the tower became an art gallery. To the left of the tower, part of the middle floor was the reading room, while the top floor housed a spectacular display of stuffed animals and birds displayed in their natural habitats in large glass cases.

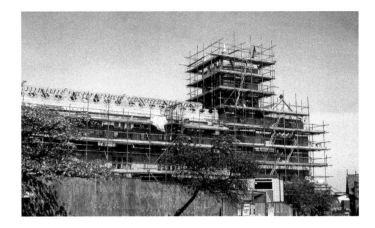

In October 1976 the library was moved to temporary accommodation in Raven Meadows and over the next two years a detailed survey of the building was carried out. The buildings either side of the tower were found to be in a very poor state with bowing walls putting pressure on the outer stonework and roof. A complex scaffolding brace was designed and fitted around the building in the first months of 1977. Work to restore the building began in June 1980 and took around three years to complete at a cost of over three million pounds. The newly restored library was officially opened by Princess Margaret on 18 May 1984.

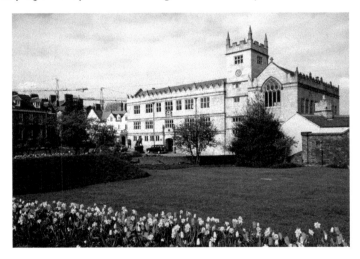

During the restoration the work on the walls brought out the rich colour of the stonework. The building to the left of the tower was built in 1630 during the reign of Charles I, whose coat of arms is below the central window of the top floor. Either side of the arched entrance are the statues of Philimathon and Polymathon, the scholar and the graduate who are both clothed in Jacobian dress. Between them is a plaque written in Latin which states 'If You Love Learning You Will Learn.' The statue in front of the building depicts Charles Darwin, who was born in Shrewsbury and is the school's most famous pupil. The bronze statue, unveiled in 1897, was the work of Horace Montford, a local sculptor.

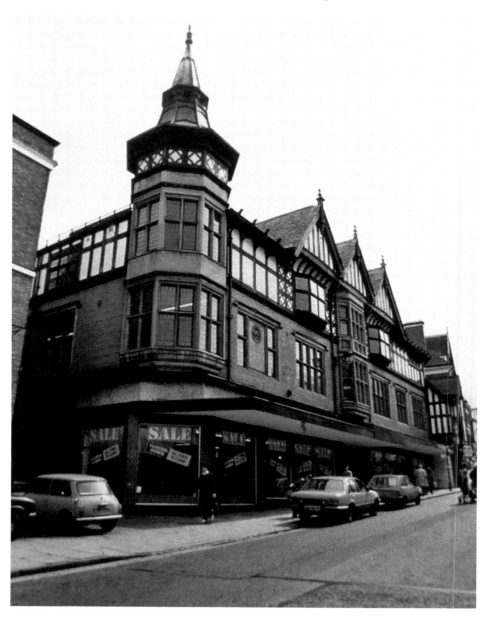

Shrewsbury Co-operative Society's new registered office and central emporium was opened on Wednesday 31 October 1923. The architect was F. E. L. Harris, who was thanked by the mayor of Shrewsbury 'For the magnificent service he had rendered the town by the erection of such a beautiful building'. It was reported that when the doors were opened for the first time, 'The arcade and all the departments were filled to overflowing and the café staff were swept off their feet in the rush.' The building was erected on the site of Thorne's Mansion, where it's believed Maria Fitzherbert, the morganatic wife of George IV, was born. She was the niece of Sir Edward Smythe of Acton Burnell, who had rented the house in 1756.

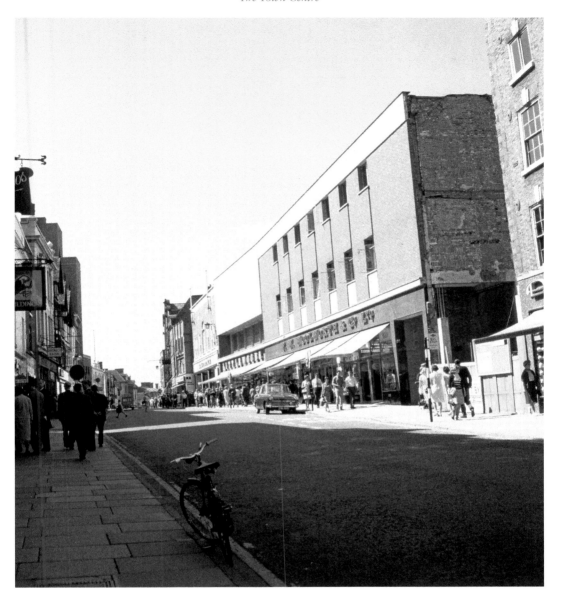

This is a view of Castle Street with Woolworth's store on the site of the old Raven Hotel. The store opened on 30 October 1964 and closed during the winter of 2008. The Littlewoods store to the left opened two months earlier and occupied the site of Newton's gentlemen's outfitters and Whitfield's ladies' dress shop. The stores were erected by John Laing and tragically during the construction of Woolworth's store a workman was killed by a falling concrete floor slab. When Littlewoods closed the store was absorbed into Marks & Spencer's store. At this time the road was open to two-way traffic and you could leave your bicycle on the kerb unlocked and unattended while you shopped and it would still be there when you got back!

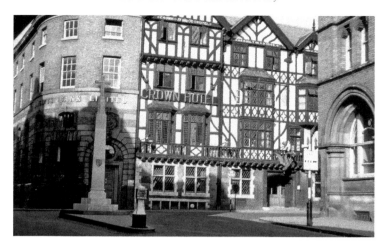

Apart from the cross at the junction of Castle Street and St Mary's Street at the top of Pride Hill, nothing else remains. The Crown Hotel was built in a mock Tudor style by the Church Stretton Hotel Company and opened in August 1901. During the Second World War it was commandeered by the military as an officers' residential club for British servicemen. After the war it was refurbished and continued as a hotel until it was sold in 1959 and demolished three years later. The magnificent red dragon over the main entrance was carved out of solid oak by a Russian émigré soon after the hotel opened. Barclays Bank to the left was rebuilt in 1959 and the Victorian post office on the right was replaced in 1963.

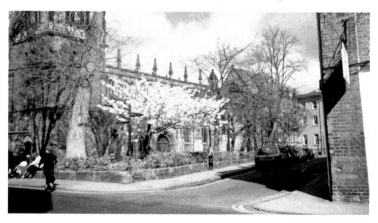

A beautiful display of blossom in St Mary's churchyard on the corner of St Mary's Street and St Mary's Place. There was a church on this site in Saxon times but it was rebuilt in AD 1150 with several additions over the years. The church houses a magnificent display of stained and painted glass, collected from all over Europe. The finest of these is the Jesse Window in the east end, which once adorned the church of the Franciscan Friars at the bottom Wyle Cop before being moved to old St Chad's Church where it remained until the collapse of that building in July 1788. The building at the bottom of St Mary's Place is the Royal Salop Infirmary, rebuilt in 1830, closed in 1977 and turned into the Parade Shopping Centre and flats.

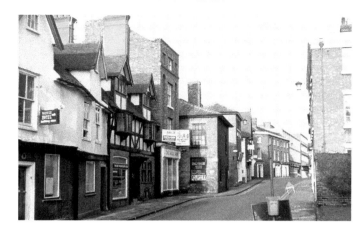

This view is looking up Dogpole towards St Mary's Street. The Warwick Hotel on the left is housed in a seventeenth-century timber-framed building that's covered in plaster. In 1961 it was in danger of being demolished and the site turned into shops on the ground floor with offices above. Thankfully this never materialised and today after a complete makeover and a change of name to Cromwell's Inn, it's a lovely small hotel in the heart of Shrewsbury that boasts an oak-panelled restaurant, beamed bistro bar and a beautiful walled garden. The house to the right was an inn called the Hen & Chickens. It was first recorded in 1786 and was in existence for just over 100 years. At the top, in St Mary's Street, are two hideous 1960s buildings erected directly opposite the medieval church.

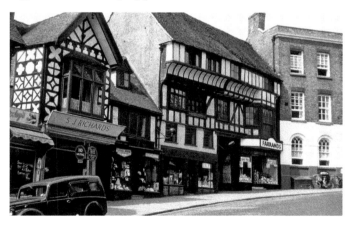

This is part of the steep curve at the top of Wyle Cop. The building on the right is part of the Lion Hotel, an old coaching house on the London to Holyhead Road. The timber-framed building is known as Henry Tudor House, where Henry is reputed to have spent the night on his epic march from Milford Haven to Bosworth. His defeat of Richard III at the Battle of Bosworth Field put him on the English throne and heralded in the magnificent Tudor era. Running through the centre of the building to Belmont Bank is Barracks Passage. The small building to the left was a pub called the Compasses. It had only a short life but is commemorated by another narrow shut known as Compasses Passage.

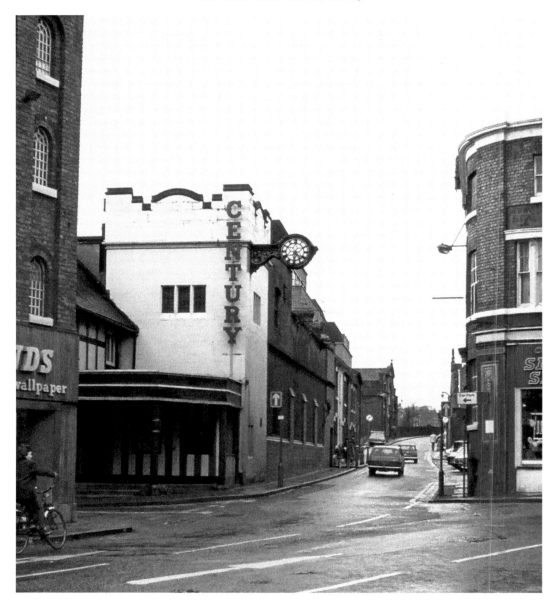

At the bottom of Wyle Cop on the corner of Beeches Lane and St Julian's Friars was the Century Cinema. It was opened as the King's Hall cinema on 12 March 1914. The first film was *Secrets of the Sea* with prices ranging from 3*d* on the ground floor to 1/- in the balcony, which had the added attraction of courting couple seats. Sound was introduced on 1 September 1930 and Cinemascope in January 1955. It closed as a cinema on 10 June 1960; the last film to be shown was Treasure Island starring Robert Newton. It became a bingo hall until 1973 and was demolished in 2003 when apartments were built on the site. The building to the left was the Corn House Restaurant but is now the House of Grain, while the building on the right is the Sleep Shop, the longest-established bed and nursery retailer in Shropshire.

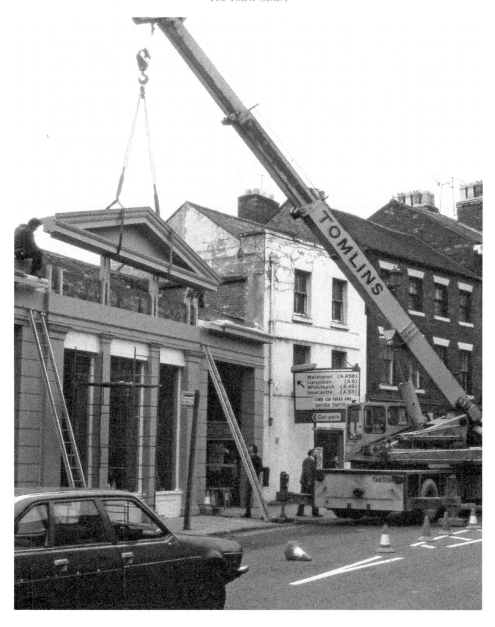

The section of road from the bottom of the Cop was known as Under the Wyle. The new frontage to Gordon Manser's antique centre is just being lowered into place – they were moving there from their shop on Castle Gates. Over the years the building has been put to a variety of uses. Towards the end of the nineteenth century it became a Salvation Army Barracks before being occupied as a warehouse for R. Maddox, who had a large departmental store in the middle of the town. During the Second World War it was converted into a mortuary for the US Air Force. In 1965 Tony Connerty spent over £8,000 converting it into a nightclub and bar called the 7Club. The building to the right was an inn called the Wherry before becoming a Chinese Laundry.

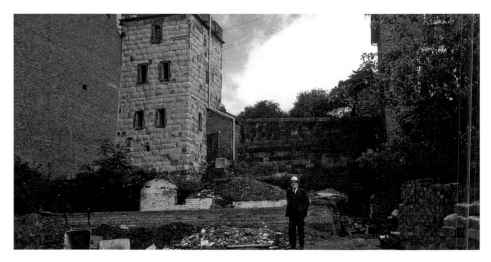

Mr Thomas Gordon Hector inspects the site of his son's new home just outside the old town wall. After the Welsh captured the town in 1215 the king ordered that a stout wall should be built around the whole perimeter of the town. The wall was strengthened by watchtowers placed at the most venerable points; the exact number is not known but it is believed to be around twenty. This is the last one left standing and is known as Wheeler's Tower. It has three floors and is illuminated by narrow openings ideal for firing arrows through. The tower is owned by the National Trust and is open to the public on eight days in the year.

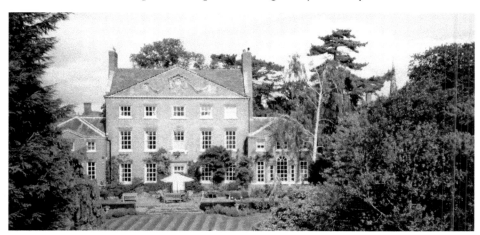

This view of Swan Hill Court House was taken from the top of the watchtower around 1960. The house was designed by local architect Thomas Farnolls Pritchard for the Earl of Bath in 1761. It then passed to the Duke of Cleveland and then to Lord Barnard. The house has been recorded as 'a fine country mansion erected in the town when land was still available'. Its five-bay centre block is flanked by pavilions with Venetian-style windows, and it has a highly ornamented pediment. The interior contains beautiful plasterwork, probably executed by Nelson and Bromfield, two of Pritchard's expert team of craftsmen.

GONE BUT NOT FORGOTTEN

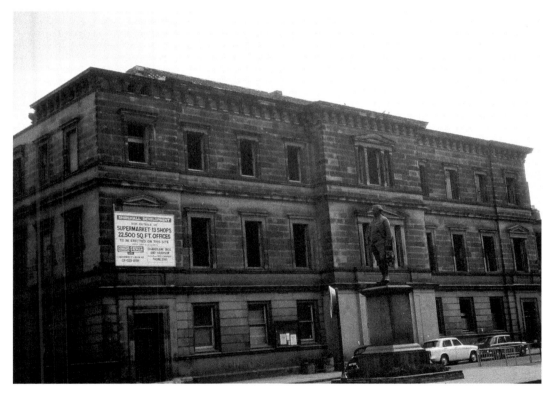

This was the second Shirehall to be built on this site in The Square. The first one lasted only forty-nine years. It was built on marshy ground, the foundations were not deep enough and in 1832 Thomas Telford found that the wooden piles on which it was built had completely rotted. This building was designed in the Italian style by Sir Robert Smirke and built by Messrs Birch & Son, who guaranteed sound foundations of concrete. It was completed in 1837 and cost around £12,000. The county council moved from this site to a new Shirehall at the top of Abbey Foregate in 1966 and the old building lay empty until it was demolished in 1971.

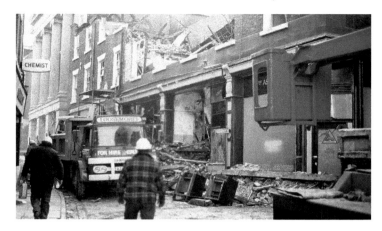

This is Market Street looking up towards the Music Hall after the devastating fire that completely destroyed Talbot Chambers on Tuesday 12 February 1985. It was once the town house of the Ottley family of Pitchford before being converted into an inn called the Talbot. The inn flourished and in the early part of the nineteenth century it was a rival to the Lion Hotel in the coaching trade. However with the arrival of the railway, trade fell off and it closed in 1851. In its heyday the inn's guests included the young Princess (later Queen) Victoria in 1832 and Daniel O'Connell, a leading campaigner for the emancipation of Catholics and the repeal of the Corn Law. He is reputed to have addressed a large crowd from one of the first-floor windows nearest the Music Hall.

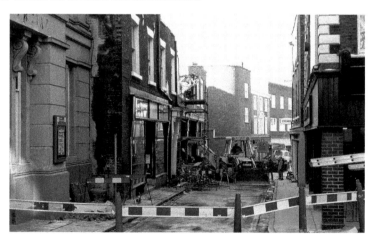

This is the view of Market Street looking down towards the Trustees Savings Bank on the corner of Swan Hill. The fire devastated the building and the site was completely cleared before a new one was erected. The only part of the building to survive is the doorway with the two Talbot heads (in the centre of the photo), which has been incorporated into the new building. A Talbot was a breed of dog that is now extinct. The building belonged to the Roy Fletcher Estates and was split into offices on the top floors. On the ground floor the shops included Hares Fashion and Junior Wear, PDC Copyprint, The Children's Book Market and Bridleway on the corner of Swan Hill.

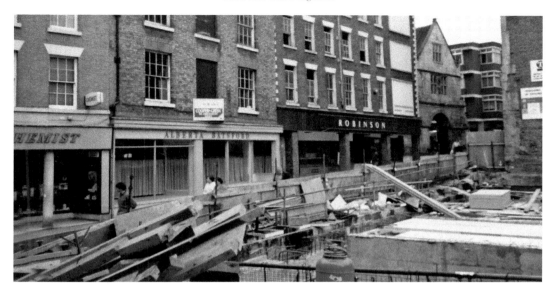

The open site left by the Market Street fire gave a unique opportunity to view the buildings on the opposite side of the road from Swan Hill. Top right is Princess House, erected on the site of the Shirehall buildings in the 1970s. To the left is the old Market Hall, built in the reign of Queen Elizabeth I in 1596. Then three houses from the Georgian period that have been adapted into shops on the ground floor. The largest housed Robinson's the Jeweller, who traded there for well over 100 years. In an advert for 1914 they claimed to be 'the oldest established and leading jeweller in Shropshire'. The empty shop in the middle was once occupied by Alberta Batsford, a popular ladies' wear shop. On the extreme left is Adams' chemist shop, which moved there from premises in Ireland's Mansion on the High Street.

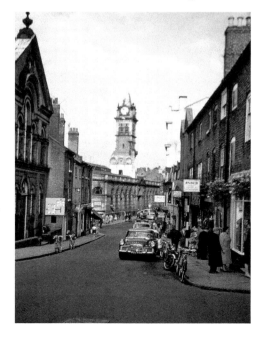

This is a view of the old market hall taken from the top of St John's Hill. Work on the demolition of the Mardol end of the market and the tower started on 24 July 1961 by a team of men from the Potteries. Work proceeded rapidly and by October a great deal of the building had disappeared. The debris was sold for between 5/- and 15/- a ton, depending on the quality. While the Mardol end was being redeveloped the weekly markets continued in the Belstone end of the old market. Once the Mardol end was completed the markets moved over so that the other end could be redeveloped. In this way there was very little interruption to trade.

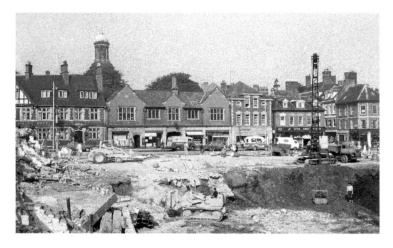

This view was taken from Shoplatch to Belstone in July 1963. One of the biggest problems with the building of the second phase was the foundation for the new tower. As they were so deep they had to be dug out by hand by a team of men working shifts around the clock. When completed the tower would be 200 feet high – around 50 feet taller than the old one. On the corner of Barker Street and Claremont Hill is the National Milk Bar while on the other corner is the Little Fruit Market. One of Sidoli's ice-cream vans is parked outside their café and cake shop to the left. The large building fronts the Morris Hall that is approached through the passage in the centre. To the far left is the Exchange Hotel.

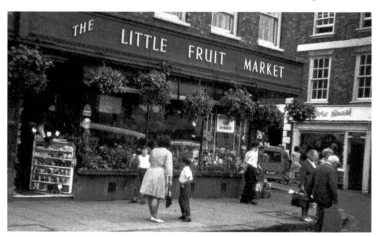

The Little Fruit Market in Belstone was always a popular business as housewives could buy their fresh fruit and vegetables before catching a bus home from the bus station across the road. The shop was opened in around 1938 after the street was widened and the shopfronts rebuilt. The shop was owned by S. J. Richards, who was also running a similar business on Wyle Cop in the 1950s. The business closed in the 1960s and Sidoli's, who had a shop and café next door, extended their business into it. When Sidoli's left it became a small hotel and restaurant called the Belstone. It has now changed its name to The Loopy Shrew.

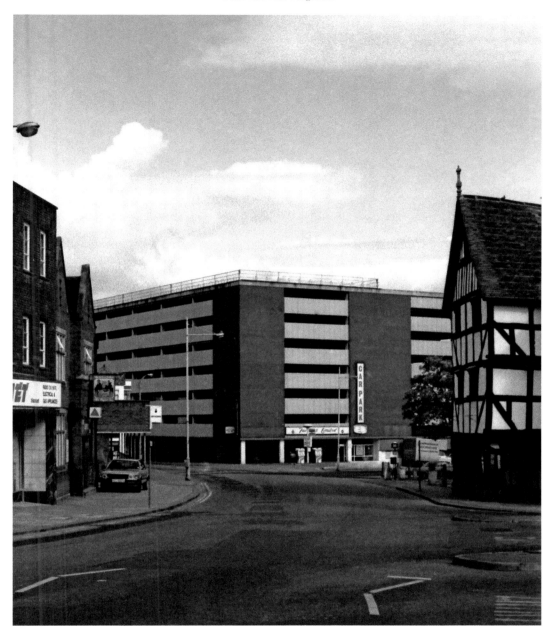

The photographer is looking down Barker Street to Bridge Street with St Austin's Friars going off to the left. In the centre is the multistorey car park that was opened just in time for the Flower Show in August 1963. It had parking for around 430 cars and Furrows opened a small petrol station on the forecourt. To the right of the petrol pumps was one of the town's first car washes. It was advertised as 'Quick and Easy', the driver never having to leave his seat, and costing only 7/6. The car park was never popular as cornering was very tight and parking spaces very narrow. The park was closed after structural faults were found in 1999 and it was demolished in August 2002.

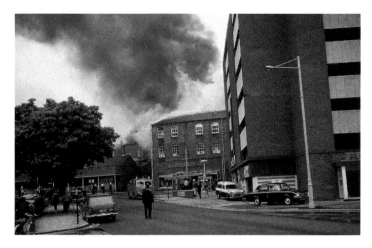

A massive fire broke out in Barker Street on 7 August 1966. It completely gutted the premises of A. D. Foulkes, a local ironmonger and building supply merchant, causing over £1 million worth of damage. The fire also destroyed a wool warehouse next door. The building was packed with around 250 tons of wool worth around £128,000. At the height of the fire loud thuds could be heard as calor gas containers and tins of paint exploded in the heat. At one point flames were seen jumping 20 feet above the roof and fire officers were concerned about the petrol station just yards away in the multistorey car park. Despite the destruction Foulkes were back in business in less than forty-eight hours.

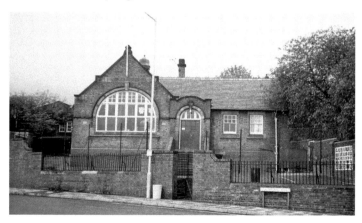

Charles Darwin's father founded St George's School in a small room in Chapel Street in 1834 and it was run by his sisters Emily and Susan. A new mixed Elementary School was built on Millington's land to the right of this building in 1880. When the School Board took control in 1882 the boys and girls were segregated. The school grew rapidly, causing the boys to move out into this new school on 30 August 1897, leaving the girls and infants in the old buildings. The boys and girls were reunited on the two sites in the 1970s when Kerry Jones was headmaster and finally moved out to a new school in Woodfield in 1982. This building was demolished in April 1994 and new housing was put on the site.

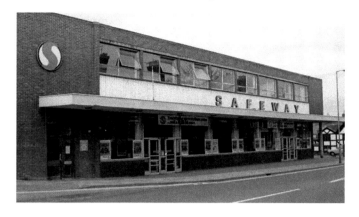

Safeway opened their first store in Abbey Foregate on Thursday 6 August 1964. They advertised in *The Chronicle* as 'Real one stop food shopping at last', and 'The finest food show in town', which made it an immediate hit with the public. Within the store there was a bakery, delicatessen, fresh fish counter and snack bar. They were also open longer than conventional food outlets: on Tuesday, Wednesday, Thursday and Saturday 8 a.m. to 7 p.m., Friday 8 a.m. to 8 p.m. with half-day closing on Monday 8 a.m. to 1 p.m. Bargains on the first day included potatoes at 1/- for five pounds and pure lean minced beef at 3/6 a pound. The firm moved to a larger store in Old Potts Way and this building was demolished in 2001.

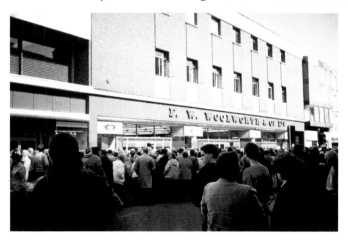

Woolworth's opened their first store in Shrewsbury at Nos 20, 21 and 22 Pride Hill around 1928. They adapted the premises of Bagnall & Blower, grocers, and Steward Bros, provision merchants, into a bazaar selling a variety of items at a low price. They opened this store on 30 October 1964 on the site of the Raven Hotel, to coincide with the start of the busy Christmas season. It was the first store in the town to install an escalator that was able to move 7,000 shoppers an hour between the two floors. In 1987 the store was extended and the rear incorporated into the new Darwin Centre. To celebrate the extension the firm revamped their shopfront, which got them into trouble with the town planners. The store that was known affectionately as 'Woolies' closed on 3 January 2009.

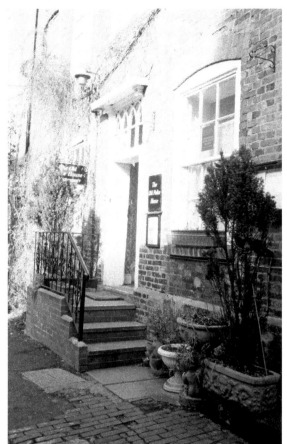

Left and below: These two photos are of the Old Police House situated up a narrow opening on the north side of Castle Street. The location is Castle Court, which was formerly known as Sydney Court. It's an early eighteenth-century Grade II-listed Georgian house that was once used as a courthouse and gaol, with the cellars of the house still incorporating the remains of the prison cells. In the 1970s and 1980s it was a popular restaurant known as the Old Police House. It was then sold as a private house to a man who dealt in postage stamps and then to the well-known children's author Pauline Fisk and her husband.

In the 1980s the proprietor of the restaurant was Rudd-Clarke, whose attention to detail and the consistent high standards achieved by him and his chef David Campbell earned the restaurant much-deserved entries in the 1986 editions of the Michelin Guide, the Good Food Guide and the Family Welcome Guide.

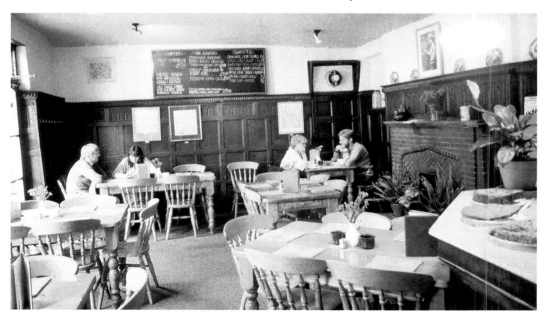

This is Chester Street looking towards Smithfield Road. All the buildings on the right have been demolished, completely altering the character of the street. The United Yeast Co. Ltd occupied the buildings on the right; Watkins Commercial House Hotel occupied the building with the bay windows; and the next building housed a grocery shop owned by S. Vincent, who later established a taxi firm there. The large white building is the Chester Street side of Charles Clarke's garage and showroom and behind the cyclist is their parts department on the other corner of Smithfield Road. Above the roofs you can see the tower of the library.

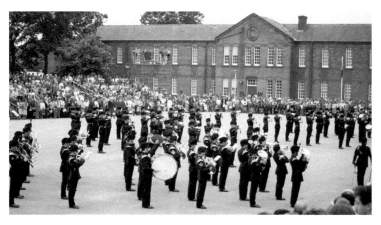

The Farewell Sounding of the Retreat to the public at the Sir John Moore Barracks, Copthorne, on Monday 23 June 1986 marked the end of an era. The ceremony signalled the closure of the Barracks as a centre of basic training for recruits to the Light Division, as this depot and the one in Winchester were to be amalgamated in a new £19 million Sir John Moore Barracks in Winchester. The finale included Verdi's 'Speed Your Journey', 'High on a Hill', 'Fanfare' and a very emotional 'Sunset' as the flag was lowered over Barrack's Square for the last time. The building of the Barracks cost £65,000 and it was first occupied by companies of the 53rd Shropshire Regiment and the 43rd Monmouthshire Light Infantry on 30 December 1880.

The photographer is looking down Claremont Bank to Lower Claremont Bank with the wall of the Priory School on the left and St Austin's Street on the right. The street commemorates the Austin Friars who established a religious house close by. The buildings in the centre are part of Morris's warehouse erected in the 1970s to replace their old facilities that had been part of the Circus Brewery. The blue door is the entrance to their garage that was built in the 1960s to house and maintain their fleet of delivery vans. In 1972 the company bought the gasworks site in Castle Foregate and built a new garage there to maintain their vehicles. This site has since been redeveloped into Montgomery's Tower, a JD Wetherspoon inn.

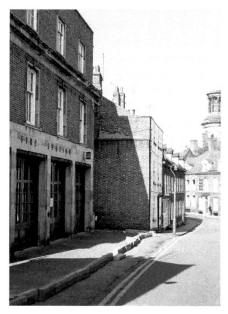

The Shrewsbury Borough Fire Brigade was formed in March 1917 and was under the command of the chief constable with all its members being drawn from the Borough Police Force. Their first fire station was under the market hall on the corner of Claremont Street and Belstone. This station was opened on Cross Hill on 30 June 1938 by Alderman Ashton, the chairman of the Watch Committee. It was originally a two-storey building, the third storey being added in the early 1950s to provide a canteen and recreational facilities for the men on duty. In 1973 the fire station moved to new facilities in St Michael Street and this site was redeveloped into sheltered housing.

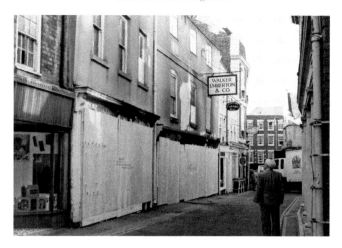

This fire occurred in Princess Street on Friday 13 October 1989 at the premises of Walker Emberton, who sold furnishing and fabrics including everything from towels and curtains to tableware and bedding. The blaze, which caused over £250,000 worth of damage, was thought to have been started by a burglar who had also entered Candle Lane Book Shop next door. The firm, founded in August 1946 by business partners John Walker and Reginald Emberton, recovered and continued to trade from there until October 2006. The sign for the shop is hanging on a metal bracket once used to hold the sign of the Bell Inn that occupied the premises from the sixteenth century through to 1925.

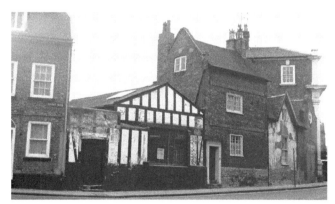

This dilapidated building was once the home of the Exchange & Mart that was also known as Fortunate Finds. The proprietor was Howard Newman and his shop was packed with antiques and curios where you could spend hours browsing. It was a Mecca for budding philatelists and cigarette card collectors as he had stock books bulging with postage stamps and you could purchase a pack of ten assorted cigarette cards for 3*d* up to a full set of fifty for as little as 2/6. On Saturday mornings after the children's matinee at the Empire the shop would be full of children looking at the stuffed crocodile hanging in the entrance and the variety of African spears and shields in the main shop. Soon after this view was taken the shop was demolished and small house built on the site.

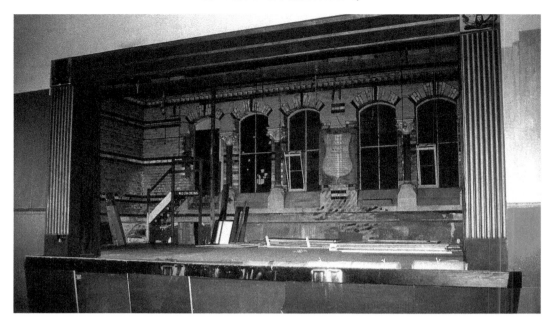

This is the stage that was built in the main area of the Working Men's Hall in Princess Street. The foundation stone was laid by Mrs Wightman, the wife of the Vicar of St Alkmund's who was a great temperance fighter and did a great deal of good for the poor people of the town. It must have given her great satisfaction as it was built on the site of the Fox Inn. The hall was opened in 1863 and contained refreshment and reading rooms, baths and a lecture hall. During the 1940s and 1950s the hall was converted into a theatre for the Shrewsbury Repertory Company and then into an antique market. In 2015 it was reopened as a multipurpose arts and events venue known as the Wightman Theatre.

This is St Mary's Place looking towards the Nurses' Home on the right. To the left with the rounded wall is Windsor House, which was erected in the late eighteenth century and has an almost complete interior dating from that period. The partially built house nearest the camera was known as the Star of David House as it carried that symbol on the front of the building. It was built in the 1960s as offices but many people in the town thought it was going to be a synagogue because of the emblem. Building had been halted as it blocked off light to nearby buildings. A couple who were renovating the timber-framed Windsor Lodge at the rear had it demolished in 1979 and replaced by a garden and parking space.

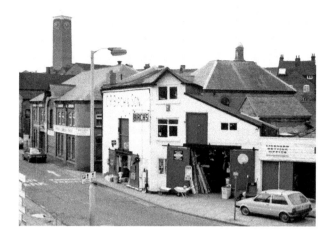

C. R. Birch & Son founded their hardware shop in 1909 and it was run by three generations of that family. The store was ideally situated opposite the old cattle market and the Tuesday market was a busy time for the business until the market was resited to Harlescott in 1959. As well as selling a wide range of hardware and household goods, the firm also delivered fuel and lubricating oil to farmers and central heating oil and paraffin to customers across Shropshire. The shop was an Aladdin's cave of useful items and the service was second to none. However with trade moving out of the town centre and strict parking restrictions around the store, trade dwindled and with great sadness, after 105 years of service to the town, it closed on 31 December 2014.

St Mary's Catholic School was located on Town Walls next to the cathedral. In the nineteenth century before the school was built Catholic children were taught in a house on Wyle Cop and later in the tower at the far end of Town Walls. A school was erected here around 1877 and rebuilt in 1892 to accommodate 140 boys and girls and 129 infants. The teaching staff were all nuns from the Sisters of Mercy. At one time the infants' was known as St Joseph's School and the juniors' as St Mary's School. The school moved to a brand-new site in Castlefields in 1970. This building lay empty for several years but in 1984 it was used as a workshop for making scenery when the film of *A Christmas Carol* was shot in the town. Later the site was cleared and eight large town houses called Bishopstone Mansions were built on the site.

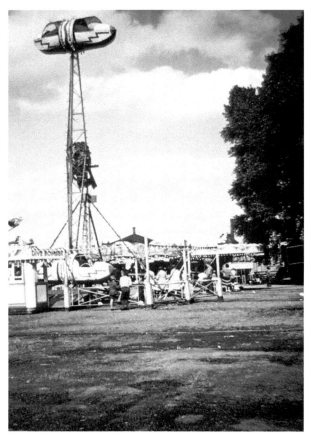

In the 1950s and 1960s before Frankwell car park was created all the funfairs and circuses visiting the town were located there. This is Pat Collins' fun fair that used to visit the town twice a year and there was always a superstition among the locals that the fair's arrival always heralded a period of rain. The ride in the foreground is the Dive Bomber that swung you round 360 degrees on the large arms, while the cab rotated 360 degrees in the opposite direction. Other great favourites were the big wheel, the rotor and the chair-a-planes. In the early 1960s each ride cost 6*d*. The favourite sideshow was the boxing booth where locals would try to last three rounds for a cash prize.

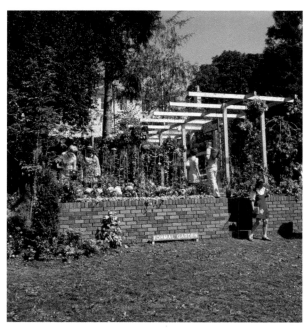

This formal garden was laid out at the top of Salt's Field next to the Kingsland Bridge in the Quarry. It was the work of the Telford Development Corporation, who set it up as their contribution for one of the Flower Shows in the 1980s. It had brick walls, paved walks and a pergola and the flower beds were packed with small trees, flowering shrubs and seasonal bedding plants. It faced west and on a summer's evening it was a delight to walk or just sit and admire the beauty of it all. Unfortunately it had only a short life as it attracted some unsociable behaviour and was dismantled.

OUTSIDE THE BRIDGES

This photo was taken in the 1970s before the gyratory system had been put into place. Note the car coming out of Abbey Foregate before the one-way system was introduced. The Congregational Church was designed in the Gothic style by George Bidlake of Wolverhampton and was opened for worship on 31 May 1864. In 1972, when the Congregationalists and Presbyterians united, it became a United Reform church. The English Bridge was designed by John Gwyn and was opened to traffic in 1774. It was modified between 1925 and 1927 by the Borough Surveyor Arthur Ward, who drew up plans to rebuild it, using as much of the original stone as possible.

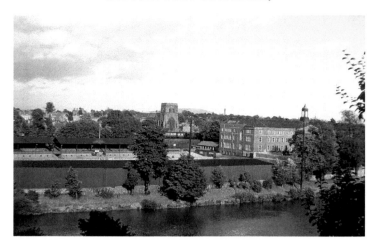

This view across the river to Abbey Foregate was taken from the rear of the Royal Salop Infirmary, which is now The Parade. The Georgian-style building on the right was built as the Technical College in 1938. It became the Wakeman School in the 1960s, named after Sir Offley Wakeman who was chairman of the county council and is now part of the Sixth Form College. Directly opposite on the bank of the river is the Gay Meadow, once the home of Shrewsbury Town Football Club. They moved there from a pitch in Copthorne that was opposite the Barracks. Their first league game at the Meadow was against Wolverhampton Wanderers Reserves, which they lost 2-1. The club moved from there to a new stadium in Meole Brace in 2007.

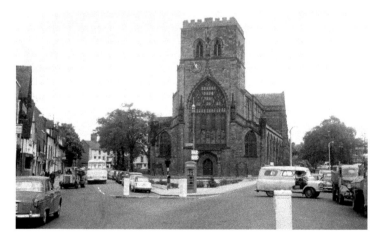

The Abbey of St Peter and St Paul was founded on the site of a small wooden Saxon church by Roger Montgomery, the first Norman Earl of Shrewsbury in 1083. The church has not altered much in recent years, apart from the cross on the tower, but the road layout has. In this view the north side is still open to two-way traffic and the telephone box has been removed. Originally when leaving town all traffic went to the left of the church and across the rear. It wasn't until 1836 when Thomas Telford was building his London to Holyhead Road that the road to the right was put through the old monastic remains to save a few seconds of time.

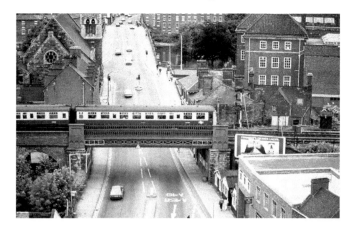

This view looking back towards the English Bridge and town was taken from the top of the Abbey tower before the gyratory system was installed. On the right is the old Technical College and on the left behind the United Reform Church is the National School erected in 1772. The railway bridge was built to take trains over the main road and then on to Hereford and Wales. It was reconstructed in this style in June 1932. Bottom right is the 1960s block containing a branch of Lloyds Bank; it was erected on the site of the Bull Inn. The three wooden cabins between the railway bridge and the bank have housed several businesses including cycle, fishing tackle, newsagent and antique shops, and a boot and shoe repairer.

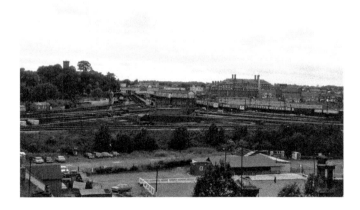

This view was also taken of the tower of the Abbey looking towards the railway station. In the foreground is the Telesports bowling green and clubhouse and in the bottom right-hand corner the barleycorn chimneys of the Abbey Alms Houses. The large building in the centre of the railway tracks is the Severn Bridge signal box, which is the largest mechanical signal box in the world. It is around 70 feet long and contains 180 levers. The building on the skyline with the four chimneys is Shrewsbury Prison in Castlefields. On the left, behind the trees, is Laura's Tower in the castle grounds. It was built on the old castle motte by Thomas Telford for Sir William Pulteney's daughter Laura.

The buildings top right are at the rear of the Queen Anne House in Abbey Foregate that is now occupied by Shropshire Wildlife Trust. On the left is the railway viaduct. The photograph was taken in 1986 during an archaeological dig. It revealed these fourteenth-century walls and from the artefacts found there it's believed formed part of a kitchen that was linked to the infirmary building. The far wall is thought to be even older, dating from the early thirteenth century. One of the most important items to be found on the dig was a silver bowl dating from around 1400. The remains are protected under the present car park.

A new road was built joining the Column/Meole Brace Link Road to the Telford Way in 1988. The stakes on the racecourse at Monkmoor marked the line of the new road that would be dug several feet below ground level to allow it to pass under Monkmoor Road. The new road went through the tennis courts on the recreation ground and two pairs of semi-detached houses on Monkmoor Road. A digger used in the demolition is located between the houses in the centre. During the summer of 1988 the road had to be closed for a whole weekend to allow concrete joints on the new bridge to harden. From this point the road veered to the right to pass St Peter's Church, which can be seen between the houses on the right.

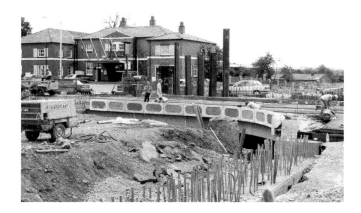

The new road also had to go under Abbey Foregate and again a great deal of disruption was caused. To achieve this, huge piles were sunk into the ground to hold back the earth on either side while the two halves of the bridge were completed. This meant that traffic lights were used for several weeks, allowing just single-lane traffic across the Foregate at this point. In the background is the Lord Hill Hotel named after Sir Rowland Hill whose column stands nearby. It was formerly a house called The Shrubbery and was occupied by John Bagnall, who ran a successful grocery business in the town in the nineteenth century. After being extended it became a hotel in November 1964.

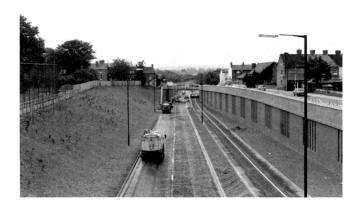

The new road follows the line of an old railway track that was filled in with household rubbish during the 1950s. It was named Bage Way after Charles Bage who was instrumental in designing the Flax Mill in Ditherington, which was the first iron-framed building in the world. The new road was officially opened in the summer of 1990 by Prince Philip, who joked that he wasn't sure whether he was opening a new road or inaugurating a traffic jam. The road, which cost around £10 million, was the biggest scheme undertaken by the Shropshire County Council and was designed to ease the north–south traffic flow away from the town centre. The road on the right is Bell Lane, which runs down to Abbey Foregate and is named after the hotel on the corner.

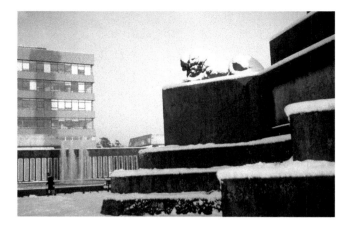

This photograph was taken just before Christmas in 1967. The Shirehall, which was formally opened by the Queen in March, had been in operation for just over a year. The fountains were an attractive feature before a bland 1960s building and it was a popular place on a hot summer's day for parents to take their children for a paddle. Unfortunately the fountains were vandalised several time and beer bottles were broken and thrown into the water, making it a danger to the children. The pool was filled in and planted with shrubs. The Lion is one of four that guard the bottom of the Column and was the work of Stonemason John Carline, whose home and works were next to the English Bridge.

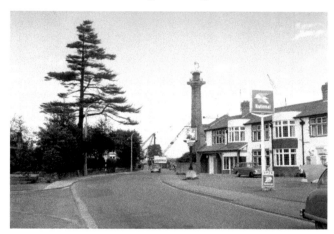

This view was taken from Wenlock Road in 1964 with the cranes on the site of the new Shirehall. In 1945 a plan was presented to the council to build all Shrewsbury's public buildings around the Column in a Georgian style. This was to include a new Shirehall, police, fire and ambulance stations and a 1,000-bed hospital. Only the ambulance station, opened in 1954, and the Shirehall were ever built. The White Horse inn was erected in the 1920s on the site of the old inn and has been recorded since before 1780. It is referred to in this rhyme about the inns in Abbey Foregate: 'The Old White Horse has tolled the Bell and made the Peacock fly, has turned the Old Bush upside down, and milked the Dun Cow dry.'

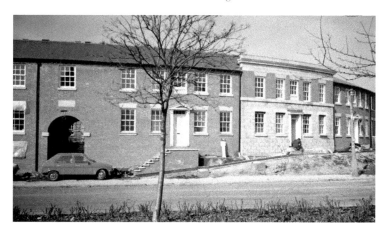

Carline Fields and Carline Terrace on the corner of Coleham Head and Longden Coleham are named after the family of stonemasons and builders whose home and works were next to the English Bridge. There were thirty-three houses on this site, which were demolished, and for a number of years the land was used as a car park and occasionally for a travelling fair. Being sited between to the River Severn and the Rea Brook the area was very prone to flooding. In the 1980s the area was redeveloped, well above the flood line, into fifty-six retirement homes. They included two one-bedroom apartments, seven three-bedroom and the rest with two bedrooms. They were bought on a ninety-nine-year lease and prices ranged from £38,500 to £46,000.

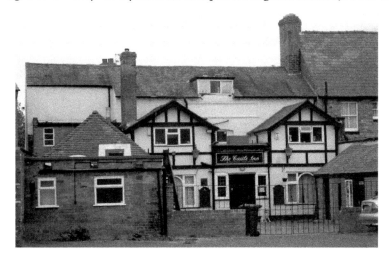

This is the rear of the Castle Inn that was opened up when Moreton Crescent was built; the front of the building is in Old Coleham. The inn was first recorded as the Bull & Pump in 1804 but changed its name to the Castle in 1856. During the 1970s Shrewsbury Folk Club held their workshops there every Wednesday evening when Len Taylor was landlord. The inn is situated on low ground, which is prone to flooding. After one of the 1960s floods Mr Taylor commented that he had paid out over £500 to repair flood damage and to redecorate. The inn closed in 2005 and is in danger of being demolished.

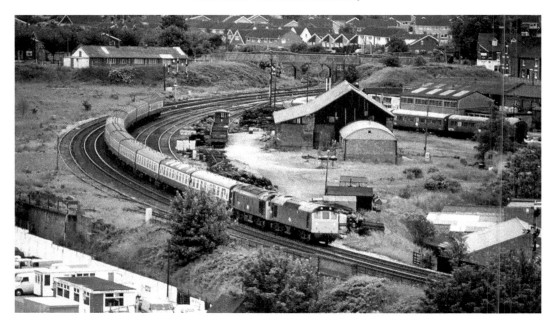

This view taken from the Abbey tower shows an area in Old Coleham that was once part of the GWR/LMS engine sheds. A double-header passenger train moves towards the railway station from Wales. The train has just gone under Sutton Bridge at the top. The building to the right of the bridge is the Rea Brook Social Club in Scott Street. It was once the railwaymen's canteen that was also used for social functions such as Christmas parties for staff children. After steam was phased out in the 1960s the engine sheds were demolished and the land lay derelict for several years.

Left and opposite: This public house was first called the Belle Vue Tavern but had changed its name to the Plough by 1868. It changed its name back to the Belle Vue Tavern in October 1991. The present building replaced a much older inn at the beginning of the twentieth century. It once had a large horse chestnut tree towering over it, but just before Christmas in 1996 a huge storm with gale-force winds blew it down. Luckily it fell away from the inn, which was full of people celebrating the festive season, just clipping the corner of the building. The road was blocked for several hours but the fire brigade and council workers had it cleared before the morning rush.

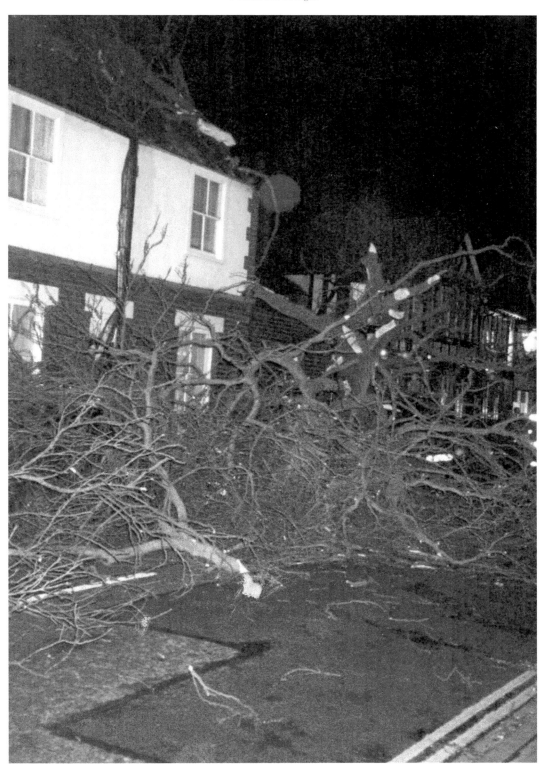

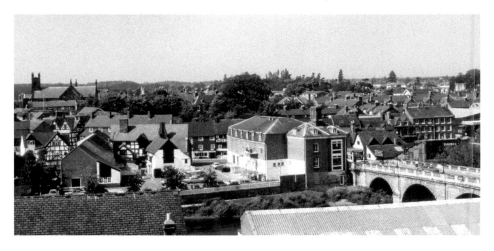

This view looking across the river to Frankwell was taken from the top of the multistorey car park in Bridge Street. The timber-framed building on the left is the Crow Inn at the top of Water Lane, which is thought to have led to the original ford used before St George's Bridge was built. To the right of the lane is the rear of the Fellmonger's Hall where sheep skins were treated through to the 1980s. The large building just before the bridge was a warehouse belonging to Richard Bromley, a corn and seed merchant. It was later converted into Hall's Auction House and is now occupied by a firm of solicitors. To the right of the Welsh Bridge is the Frankwell Forge and above the Anchor Inn on the Quay. On the skyline is St George's Church in Mountfields.

The photographer is looking from New Street up Copthorne Bank towards Greenhill Avenue on the right. The BP station on the right was built in the 1970s and was known as the Copthorne Filling Station. As well as selling petrol it also had a small convenience store and repair shop. It was built on an old sandpit where the air-raid shelters for the schools were erected during the Second World War. Just below are the M.E.B.s Substation and the fence around St George's Boys' School playground. The National Garage belonged to Green Bros, who built this on the site of their old premises. The cottages above are known as Providence View.

This is the view coming down the Mount towards Frankwell with Chapel Street on the right. All the buildings were removed for realigning the roads and the building of the Frankwell Roundabout. The buildings on the right are just below the Buck's Head Inn with the shop on the corner belonging to grocer Tommy Grain. The house on the other corner was boarded up for many years as it was the scene of a murder where a husband killed his wife with an axe. The house to the right of the timber-framed cottage was once an inn called the Golden Lion, which was open for only a short time, between 1851 and 1883.

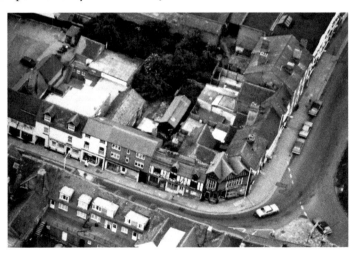

This aerial view shows the junction of Frankwell to the left and New Street to the right with just a small section of Frankwell Roundabout showing. The house right on the junction was built around 1900 when the corner was rounded to give easier access into New Street. In 1981 the timber-framed building to the left of the new shop was in danger of being demolished. It was a range of medieval shops dating from the late fifteenth century to the early sixteenth century and although the ground floors had been altered, the upper floors were still in their original state. After a great deal of negotiations between the builders and the council, some of the newer parts were demolished but the medieval core was left intact.

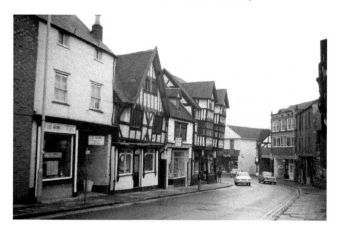

The mini car is just passing the Frankwell entrance to Water Lane. The timber-framed building on the corner of the lane is the Old Crow Inn that was first recorded in the eighteenth century, closed in 1971 and converted into flats. The building next door was erected between 1901 and 1903 by Lewis & Froggatt, who were ironmongers and bicycle salesmen. In this view it belonged to Rodington Dairy – note the milk vending machine outside. The single-gabled timber-framed building on the left dates from the late fifteenth century and was once an inn called the Bell that was mentioned in 1674 and closed in 1910. The alleyway to the left was known as Gittin's Passage, commemorating a former landlord of the inn. The impressive timber-framed building lower down was built as a single dwelling around 1620.

This is a view over the rooftops of Mountfields, looking towards St George's Church and Darwin House at the top centre. Darwin House was built by Dr Robert Darwin, the father of Charles Darwin, who was born there in February 1809. Until 1819 there would have been no more than three or four substantial villas in Mountfields, the rest of the area being divided into a number of small gardens. Gradually between 1850 and 1914 the lanes leading to those gardens became streets on which these houses were built. St George's Church was erected on land given by the Drinkwater family. It was consecrated in 1832 as a chapel of ease connected to St Chad's Church and became a separate parish in 1837.

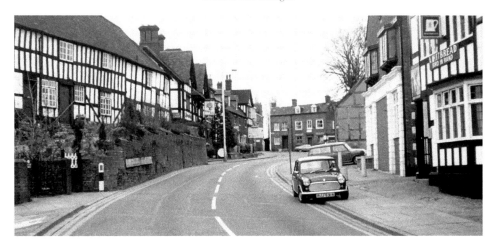

This view of Coton Hill is looking towards Berwick Road on the left and Ellesmere road straight ahead. The timber-framed cottages on the left were once part of the great barn belonging to the Mytton family. They built a large mansion on the site around 1500 that overlooked the river towards Frankwell. An undertaker who lived in one of the cottages used to display his coffins upright along the wall. There are three inns in this photograph: just above the cottages is the Royal Oak that dates from 1804; in the timber-framed building at the top is the Woodman that was first recorded in 1851; and across the road in another timber-framed building is the Bird In Hand, which is the oldest of the three being recorded from 1780. The building above was once one of Morris's grocery stores.

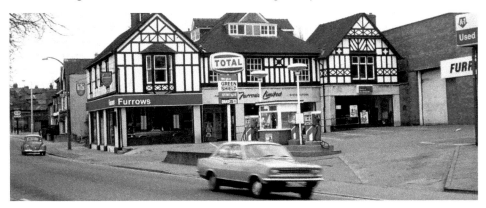

This house in Coton Hill was the birthplace of the gallant Admiral Benbow, the 'Nelson' of the seventeenth century. For a number of years in the nineteenth century it was the vicarage connected to St Mary's Church in the centre of town. Around 1910, Mark Davies, the proprietor of a garage on Dogpole, opened another branch in the garden of this house. The business was bought in 1919 by Cyril Harrison-Watson, who had founded Furrows a year earlier. The name comes from the furrows ploughed up by tractors used by Mr Harrison-Watson for a government food production scheme during the First World War. When Furrows moved, these buildings were cleared and apartments erected on the site.

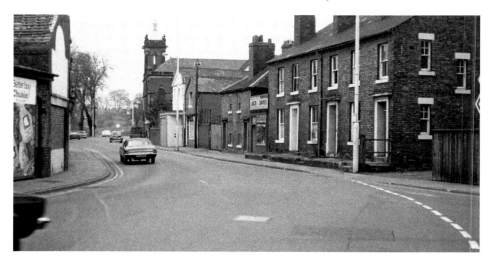

This is the junction of Chester Street with Coton Hill branching off to the left and Cross Street on the right. The building with the tower and green dome was a Congregational Church designed by A. B. Deakin and erected in 1908. The land had been donated by Thomas Pace, a building contractor, and it was opened for services on 11 February 1909. Since it closed in 1942 it has been put to a number of uses including by glaziers Matthews & Peart. The blue-fronted shop was the Castle Cycle Store founded at the beginning of the twentieth century by W. E. Davies and then run by his son Jack. Since this view the terrace houses have been completely renovated and been fitted with modern windows and doors and the cycle shop and the building to the left have been replaced by a pair of town houses.

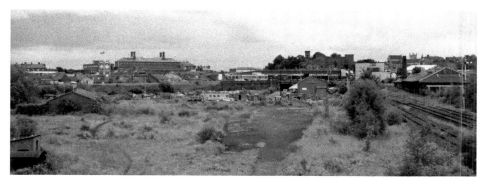

This view from Coton Hill is looking back towards the town. On the skyline from the right is the tower of the library and St Nicholas's Church. Next are the castle and Laura's Tower built on the highest part of the castle ground overlooking the river. The large building left of centre is Shrewsbury Prison, which was opened in 1793, and below the building with the tower and the flag was occupied by Thomas Corbett's Perseverance Iron Works but is now Morris's Oil Works. The railway station is just below the castle and all the land in the foreground was used by the railway. The line to the right goes to Chester, while the line on the embankment to the left goes to Crewe. The building on the right with the chimney was the engine shed of the Shrewsbury & Chester Railway, built in 1848.

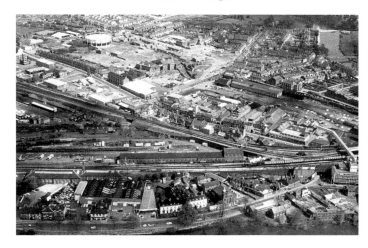

This superb aerial view looks over Coton Hill, Castle Foregate and Castlefields. A steam train leaves the station on its way to Chester. Below from the left are Furrows Garage and the Congregational Church and in the corner the old water works and Southam's Brewery on the banks of the river. Between the lines is the GWR goods yard and above the Sorting Office and Morris's Oil Works in Castle Foregate. In the top left-hand corner is the new fire station in St Michael Street and across the road the gasworks site that along with parts of Castlefields is being redeveloped. In the top right-hand corner is the Castle Walk Bridge leading across the river from Castlefields to Underdale Road and the weir.

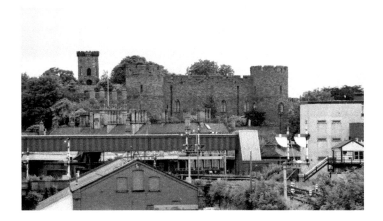

The castle stands guarding the only land entrance into the town centre. The original castle was built on a man-made motte on which Laura's Tower, on the left, was built by Thomas Telford. The first evidence of a stone building is from the reign of Henry II when the inner bailey and main hall were built. In the reign of Edward I the hall was enlarged and the distinctive rounded towers added. The chimneys and roofline of the railway station are just below the castle and the brown structure running across the view is a conveyer belt used by the post office to take sacks of mail between the station and the sorting office on the other side of Howard Street. On the right is the Crewe Junction Signal Box on Cross Street.

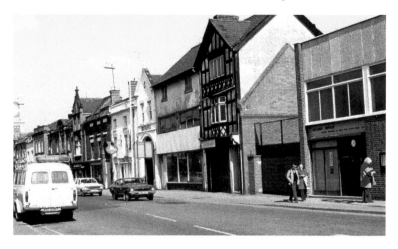

This is Castle Foregate with part of Morris's Oil Works far left and the Postal Sorting Office on the right. The sorting office moved there at the beginning of the twentieth century from accommodation in the post office building at the top of Pride Hill. The office was rebuilt in the 1960s and extended onto the site of the two buildings to the left in the 1980s. In 1894 the Shrewsbury Industrial Co-operative Society opened their first shop at No. 75 and later acquired further property to open up offices and a warehouse. This short frontage has also contained four public houses: the Crown, the Britannia (formerly called the Engine and Tender), the Bell and the Crown & Anchor.

This is the far end of New Park Road in Castlefields looking towards the Council Houses and Sultan Road. The houses on the left were called Rose Cottages. The end one was once occupied by Gresley Lewis, a local baker. At the rear of the bakery was New Hall or Lewis's Dance Hall, a popular rendezvous in the middle part of the twentieth century. Gresley took over the family bakery from his father, Charles, and opened up the dance hall in the 1930s. He later changed the name to the Studley Club, Studley being his mother's maiden name. Next door was the third public house on New Park Road, which was called the Bowling Green. It was first licensed in 1861. In 1901 it was said to have a good outdoor trade and its customers were described as working class and mostly residents living nearby.

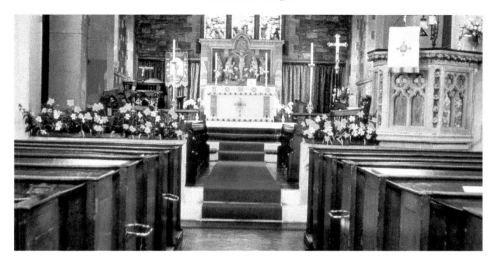

This is the interior of St Michael's Church looking east towards the high altar. The church was built in 1829 to accommodate the poor people living in the Parish of St Mary's. It was built by John Carline in the Grecian style at a cost of just over £2,000. In the graveyard there are many prisoners from Shrewsbury Gaol buried there, having died from Gaol Fever. The church was made redundant and was bought by the Shrewsbury Freemasons in 1976 for around £20,000. Although not fully converted, the first meeting was held in the Lodge Room upstairs by Column Lodge on 13 September 1979. The Festive Board was held in the open area at the top of the stairs as the dining room had not been completed.

This view was taken from St Michael Street at the junction of Crewe Street. The houses on the right facing the side of the Flax Mill were known as St Michael's Gardens. There were twelve houses in the row and they were built between 1830 and 1850. They were demolished in the early 1970s and a new row of terraced housing has been built on the site. The building on the left was a grocery shop and sub-post office and for many years the house next door was an inn called the Post Office.

The first phase of the new cattle market in Harlescott was opened in July 1956 for attested and dairy cattle, while sheep and pigs were still being sold in the town market on Smithfield Road. The town market closed when the second phase was opened here in April 1959. The new market was spread over a 25-acre site and had parking for over 1,000 vehicles. The most impressive features of the new market were the three semicircular buildings on the left that were used as sale halls for fat, barren and store cattle. In recent years the market has been moved out to Battlefield while most of this area has been redeveloped into a large Tesco Supermarket.

The opening of the Shropshire Lad coincided with the opening of the second phase of the cattle market in April 1959. The bar and restaurant was housed in a typical 1960s building, whose architecture was described as being 'in the cubist style'. On the ground floor there was a 50-foot-long bar, which was fully equipped and could cater for seventy people sitting and around 200 standing. The restaurant on the second floor could cater for 132 people in tables of four and was open early on market days to provide a good English breakfast for hungry farmers. The facility was also a popular venue for dinner dances and wedding receptions. Across the road is the Harlescott Inn, which has been replaced by a supermarket.

THE LOOP OF THE SEVERN

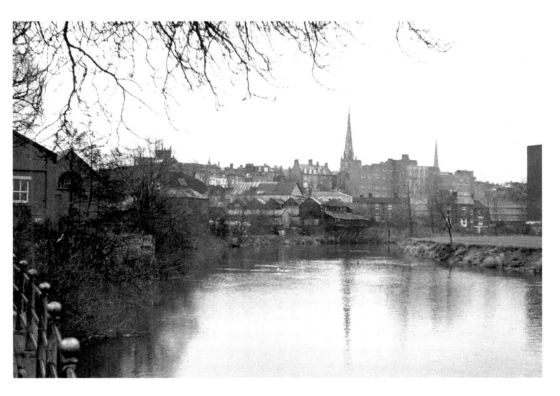

This view of the river was taken from Coton Hill and is looking back towards the town. On the skyline are the spires of St Mary's and St Alkmund's churches. Between them are the backs of Woolworth's, Littlewoods and Marks & Spencer stores. On the riverbank from the left is the old pumping station, Southam's Brewery and the rear of Woppy Phillip's yard with that marvellous building hanging out over the river. It was built when the site was occupied by Barker's timber yard so that longer tree trunks could be put through the sawmill. On the far right is Telephone House, which was demolished in 2002.

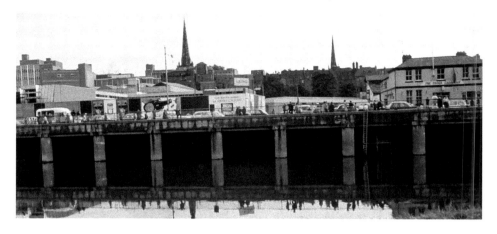

The photographer is in Frankwell looking across the river to Smithfield Road and the town centre. Plans to build Smithfield Road were submitted in August 1832 and by the end of 1835 the road had been built. During the building part of Roushill Wall that ran from Castle Gates to the old Welsh Bridge had to be removed. When opened it was the first named road in the town. The name first appears in a local directory in 1856, five years after the cattle market had been opened. By the 1920s the amount of traffic had increased dramatically and the road proved too narrow, especially on market days. It was widened between 1938 and 1939 by erecting the large pillars several feet deep into the riverbed and extending part of the road over the water. At this date the cattle market had moved to Harlescott and a great deal of work is being done to the Riverside Shopping Centre.

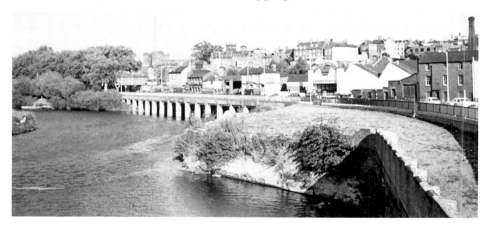

This photograph shows the full length of the extension of Smithfield Road over the river. In the distance are the castle and the tower of the library. The open ground is where Gethin's Garage once stood along with other buildings. The garage closed in 1958 and the council bought the land to widen the entrance into Smithfield Road and to create a small park. The section jutting out into the river marks the line of the old Welsh or St George's Bridge that was replaced by the new Welsh Bridge built several yards further downstream in 1795. The area is now planted with trees and shrubs and there is a concrete monument dedicated to Charles Darwin.

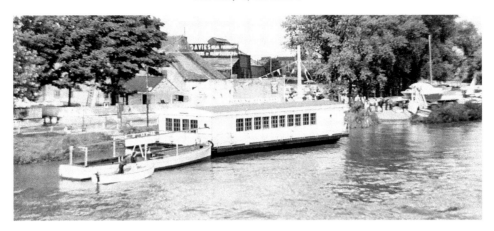

The Floating Restaurant was built in 1970 and cost around £6,000. It was supposed to be part of a £25,000 project aimed at brightening up the river. Plans also included a riverside tearoom and garden with children's amusements and a small fleet of power boats for hire, but these never materialised. It was also proposed to reintroduce a pleasure cruiser called the *Lady Sue II* after the one that used to run from the Boathouse Hotel in the 1930s. Two boats similar to the one moored to the restaurant did run for a few summers from a landing stage in the Quarry. Over the years the restaurant suffered a number of disasters, which included a tree getting stuck underneath it during a flood, another tree falling on it during a gale and during another flood being half submerged as the mooring ropes had not been slackened.

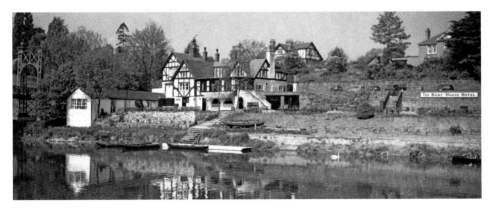

The Boathouse Hotel is situated at the bottom of New Street at the foot of Porthill. It has been an inn for over 200 years and once belonged to the Harwood family, who owned several barges that traded on the river. During the plague of 1650 it was used as a Pest House where people suffering from the disease could be isolated. The wooden steps to the river once led to a ferry where, for a ½d, you would be taken across the river. The ferry was made redundant by the opening of the Porthill Bridge on the left. During the 1920s and 1930s the hotel owned a pleasure boat called the *Lady Sue* that would take passengers upstream to their Riverside Café in Shelton Roughs. The hotel also had a fleet of rowing boats for hire until they were washed away in one of the 1960s floods.

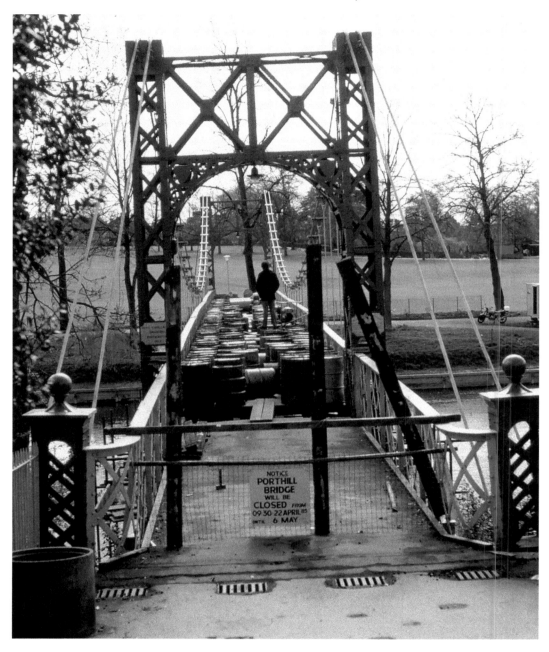

The Porthill suspension bridge was completely renovated between 22 April and 6 May 1985. It was closed to pedestrians during this time and the structure was surveyed for rust and wear. The tarmac and the wooden slats of the walkway and the main cables were completely replaced. Dozens of empty oil drums were placed over the bridge and slowly filled with water. The bridge was then monitored for movement and if it moved too quickly the water was stopped. Construction Specialist Services of Stockport carried out the work at a cost of £80,000. The bridge was originally built in 1922.

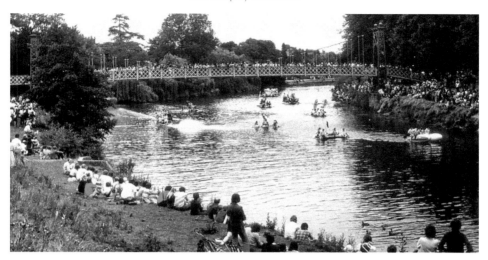

'Shrewsbury Fun Fleet Races Down The River' was *The Chronicle*'s headline on 2 August 1982. This was the fifth annual raft race to take place in aid of the Royal National Lifeboat Institution. It featured rafts of all shapes and sizes from a few oil drums and planks lashed together to Viking longboats, army landing craft, RAF helicopter and the Postcode Elephant, which had a powerful water jet in its trunk. The hundreds of spectators who lined the route and occupied the bridges between Frankwell Car Park and the Kingsland Bridge loved it. Those who got too close to the riverbank though were often the victims of bags of flour and jets of water aimed at them by the raft crews. One spectator on the Porthill Bridge had a bucket on a long rope that he filled with water to drop on the unsuspecting heads of the contestants.

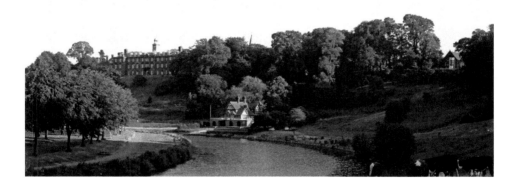

Cows graze in Becks Field on the banks of the Severn opposite the Quarry. In the distance at the top of Kingsland is Shrewsbury School and on the bank of the river is Pengwern Boat Club. The club takes its name from the place where the Princes of Powis had their palace, which may have been Shrewsbury. The club was founded in 1871 at a protest meeting, held at the Lion Hotel, against the Shrewsbury Rowing Club and its method of choosing new members. The club moved into this boathouse, which was designed by J. L. Randal and cost £1,000, in 1881. In the Quarry the new lime trees planted in the early 1950s are beginning to mature.

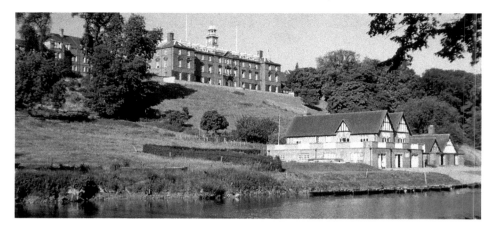

The main block of Shrewsbury School was built by Thomas Coram as a Foundlings' Hospital. Between 1760 and 1774 hundreds of poor children from London's East End were taken there to be cared for and trained for domestic service or a trade. It was later used as a linen factory, a prisoner of war camp for Dutch sailors captured during the American War of Independence and between 1784 and 1881 as the town's workhouse, known as the House of Industry. In 1882 Shrewsbury School moved there from their cramped conditions in the centre of town. The school's boathouse is built on the site of Evans' boathouse. The section nearest the camera was presented, in 1921, by the father of J. H. Pugh, in memory of his son who died during the First World War.

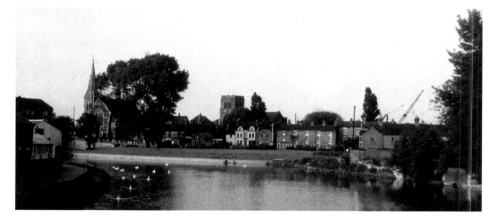

The swans paddle serenely upstream towards the Greyfriar's Bridge, where this photograph was taken from. The area just below the bridge is known as the Basin, the widest section of the river as it loops around the town. The houses on the right are in Carline Fields at the junction where the Rea Brook flows into the Severn. The buildings in the centre are on Coleham Head, which was once an island. The white building below the Abbey tower is Severn Villa and was once occupied by J. R. Morris, the proprietor of the Shrewsbury Circular that was printed in the building to the right with the rounded roof. Both were demolished when the gyratory system was built. The houses on the left were built right on the riverbank and were very susceptible to flooding.

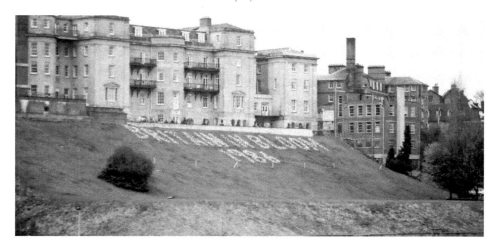

This is the rear of the old Royal Salop Infirmary that by 1987 had been converted into the Parade Shopping Centre and flats. Once there were gardens at the foot of the hospital but after a landslip in 1959 and further movement of ground in 1974 the rear was shored up to form this embankment. This floral tribute commemorates Shrewsbury's success in the 'Britain in Bloom' competition in 1986 when the town gained first place. The flowers are daffodils that were planted by Nigel Davies and Daniel Powell. The tribute was a welcomed reminder until one year when vandals sabotaged the second 'B', making it read Britain in Gloom.

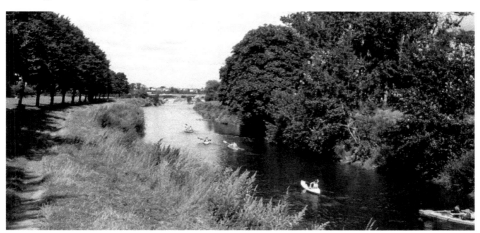

The kayaks have just passed the weir and are paddling downstream towards the newly constructed Telford Way Bridge that links Monkmoor to Harlescott. The road on the left is Sydney Avenue, the name commemorating Sir Philip Sydney who attended Shrewsbury School and was a poet, a soldier and a great favourite at the court of Elizabeth I. On the right is Goff's Island, which was created when a barge gutter was cut to bypass a fish weir. The island belongs to St Winefride's in Underdale Road and is now linked to the house by a footbridge. According to local folklore the Beatles attended a party on the island when they played in town in the early 1960s before they became famous.

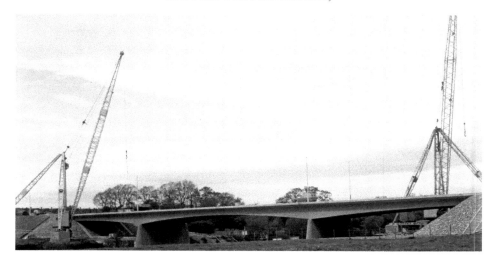

This is the Monkmoor side of the new Telford Way Bridge that links Monkmoor to Harlescott. The much-needed road was first envisaged in the Town Planning Act of 1932 but was not built for another thirty years. The overall span of the bridge is 298 feet. The piers were dug to a depth of 18 feet below bank level and approximately 3,500 tons of concrete were poured into them. Steps were also put on both sides of the bridge so that the riverside paths could be easily accessed. The bridge and link road that cost £450,000 was formally opened by Princess Mary, the Princess Royal, on 25 June 1964.

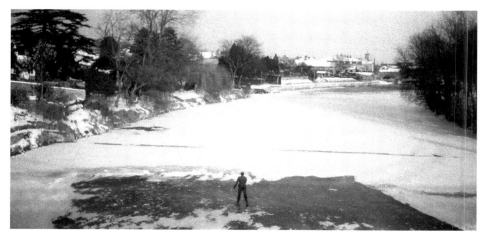

This view was taken from the Porthill Bridge looking upstream towards the Welsh Bridge during the big freeze of 1962/63. Skaters were seen on the river for the first time in twenty years. Police patrolled the riverbank with loud hailers to warn people of the dangers but they usually went unheeded. The landlord of the Boathouse Hotel had this section of ice outside his pub cleared of snow for the skaters. It was reported that he did a roaring trade selling hot toddies to skaters and onlookers. One section of the river that did not freeze was just below the Welsh Bridge; this was apparently due to warm water being pumped into the Severn from Morris's Bakery.

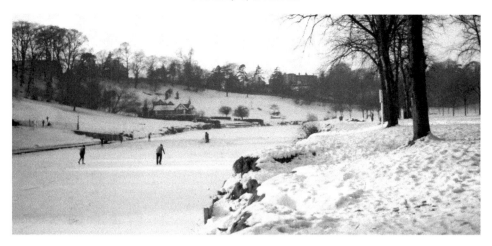

More Skaters are in action outside Shrewsbury School boathouse in February 1963. Similar scenes were seen during the severe winter of 1941/42 when boys from the schools held ice hockey matches and the masters and their families joined in the fun. This big freeze began with a terrific blizzard on Boxing Day 1962. It was followed by a sharp drop in temperatures with the thermometer staying below freezing point day and night for several weeks.

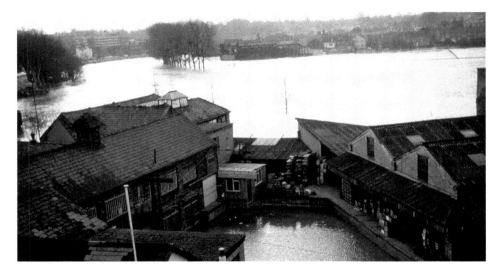

This view was taken from the top of the British Rail office block in Chester Street. The buildings in the foreground are part of Southam's Brewery in Chester Street that was demolished to make way for the Gateway Centre in 1981. The small trees are on Frankwell's County Ground on the opposite side of the river. The Frankwell Footbridge that was erected a few years after this view was taken would have started just beyond the trees on the left. What is now Frankwell car park is under several feet of water. Also flooded is the building in the centre, which is the Atlas Foundry, demolished in 2002 to make way for the new Guildhall, which has been converted into Shrewsbury University Campus.

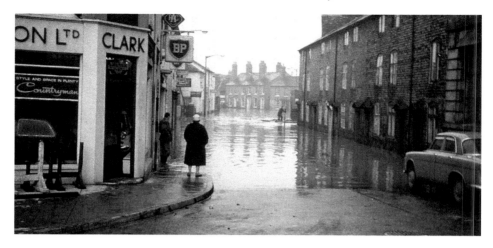

This is Chester Street looking towards the junction of Coton Hill and Cross Street during the flood of December 1960, when the water rose to a height of 18 feet 6 inches above normal. The man in the punt is moving towards the cattle-loading ramp, on the corner of Cross Street, where cattle and sheep destined for the cattle market on Smithfield Road were unloaded from cattle trucks. It was demolished soon after this flood along with the cottages that were also badly affected by the water. The two people are standing outside Austin House on the corner of Smithfield Road. The building was named after the cars sold there by Charles Clark Ltd, who opened a garage and showroom there in 1945.

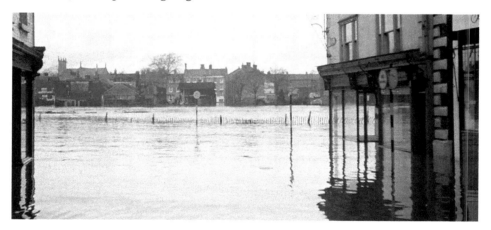

Shrewsbury was hit by several floods in the early 1960s. There were two in 1960, another in 1963 and 1964 and two in December 1965, the second occurring on Christmas Eve. This is the flood of December 1960 when the river peaked at 18 feet 6 inches above normal and over 500 houses and businesses were inundated with water. This is the bottom of Mardol looking over the river to Frankwell, with the Welsh Bridge to the left and Smithfield Road to the right, which was impassable to traffic. Behind the fence in the water is where Gethin's garage once stood, which is now the site of a small park where the memorial to Darwin stands. On the left, way above the flood line, is St George's Church in Mountfields.

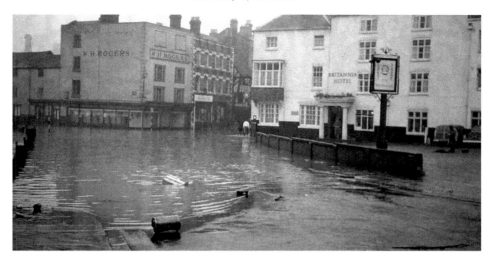

This is the same flood looking towards Smithfield Road with Mardol on the right. The water is receding but debris in the bottom right-hand corner shows the high-water mark. On the right is the Britannia Hotel, which has since changed its name to the Shrewsbury Hotel. The ground floor was badly affected by the water and the cellar was completely submerged. After the flood subsided the cellars of a number of businesses had to be pumped out by the fire brigade but a great deal of stock was contaminated by filthy water. Many families were also trapped for several days in their bedrooms and flood wardens were kept busy ferrying supplies, which included hot meals that were cooked in school kitchens around the town.

A whirling torrent of water heads downstream towards the Welsh Bridge. On the left is E. Davies' Atlas Foundry on Frankwell Quay, which is now the site of the university campus and on the right the newly built Telephone House on Smithfield Road. This is the first of the December floods in 1965 when the river rose at the alarming rate of 3 inches an hour until its peak of 17 feet 6 inches. The sixty council workers out by day and the thirty by night were kept busy ferrying people around and moving furniture in flat-bottomed punts. They also delivered meals prepared by the Women's Voluntary Service that were known a 'Meals on Waterwheels'.

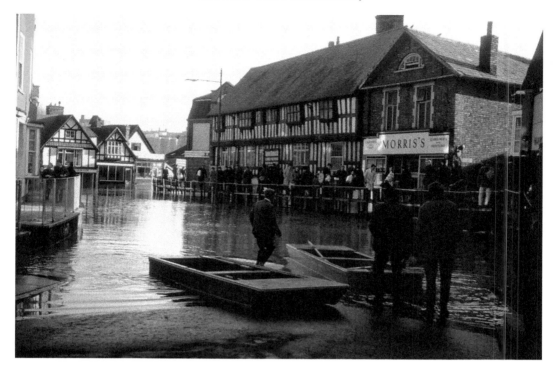

A sheet of water completely engulfed the lower parts of Frankwell leading to the Welsh Bridge on the right and the whole of Frankwell Quay. To allow people from the top of Frankwell and the Copthorne Mount area to access the town, a plank walk was erected onto the Welsh Bridge. Children loved it as it bounced up and down as you walked across, but it was not so popular with the elderly, who preferred to use a punt. During this and other floods of the 1960s the Women's Voluntary Service set up a rest place for victims in St George's Parish Hall by the Millington's Hospital.

EVERYDAY LIFE IN SHREWSBURY

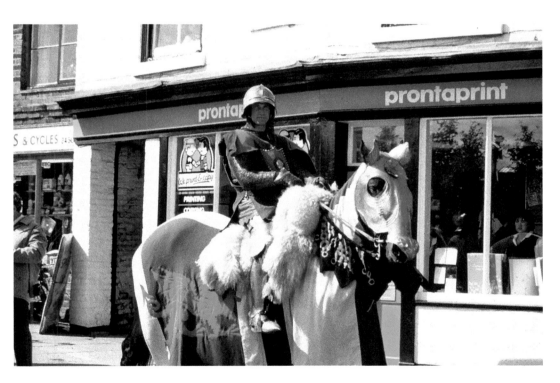

In August 1485 Henry Tudor landed at Milford Haven in South Wales and due to his Welsh ancestry enlarged his army as he travelled through the country on his way to confront King Richard III. On reaching Shrewsbury the gates were barred, as the Bailiff Thomas Mytton swore that he knew no king but Richard. However he was eventually admitted and spent the night at a house on Wyle Cop before moving off to fight a battle at Bosworth Field that put him on the throne and heralded in the magnificent Tudor era. A re-enactment of that epic 260-mile march took place in August 1985 to celebrate the 500th anniversary. Here we see Henry moving through Frankwell, his horse adorned with a large Welsh dragon.

Henry was portrayed by Geoffrey Davies. Like his predecessor he found that this journey through Shrewsbury was full of problems. On his arrival there was no welcoming committee and when he arrived at the castle, where he was to set up camp, he was informed he could not pitch his tents on the grass and to move on down to the West Midland showground. Furious with his reception, he accepted an invitation to move to Newport, Shropshire, where he was guaranteed a reception more suited to a royal personage. Before he left Shrewsbury he visited the Abbey where he was greeted by the Benedictine Abbot, played by John Quallington.

Carnivals have always been popular in the town and attracted huge crowds that packed the streets for the main parade. In the early days they were known as Cycle Carnivals, as people used to decorate and make marvellous floats from their bicycles. They were also known as Hospital Carnivals, as all the money made was donated to the local hospitals. Here Miss Shropshire is heading out of Bridge Street and turning into Mardol Quay. She was chosen from all the beauty queens from the various towns and villages in the county and the ones not chosen act as her attendants in the parade. In the background is the multistorey car park.

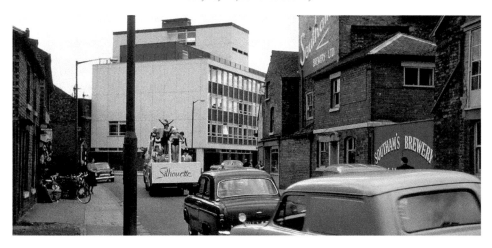

In the 1960s many of the local businesses and public houses took part and produced some spectacular floats. This photograph shows one of the most eagerly awaited, especially among the young men in the crowd. It show the Silhouette company's float with a number of attractive young ladies dressed in swimsuits and underwear making their way into town from their factory in Harlescott. They are travelling down Coton Hill towards Chester Street. On the right is part of Southam's Brewery and straight ahead is the brand-new office block occupied by British Rail Western Region built in the 1960s.

This is another Silhouette float in the carnival procession as it makes its way along Smithfield Road towards Castle Gates. The young ladies are dressed only in a black body stocking and a foundation garment made at the Silhouette factory. The company was founded in Cologne in 1887 and came to Shrewsbury from London during the Second World War. During the 1960s the firm expanded into new offices, factory and warehouse in Harlescott and opened another factory in Whitchurch. The motto of the firm was 'Every Girl Needs A Little Extra'. Note their famous logo on the funnel of the ship.

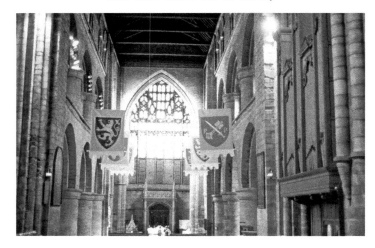

In 1983 the Abbey celebrated its 900th anniversary. As part of the celebrations, students attending Shrewsbury School of Art made these banners to hang along the nave. The one on the left represents the arms of Roger de Montgomery, the first Norman Earl of Shrewsbury who founded the Abbey in 1083. The one on the right combines the symbols of St Peter and St Paul, after whom the Abbey was named. St Peter's emblem is the keys to the Kingdom of Heaven while St Paul's sword represents his fiery nature. The year-long celebrations were a great success, mainly through the leadership of the vicar, the Revd R. J. C. Lumley, and a hard-working band of volunteers.

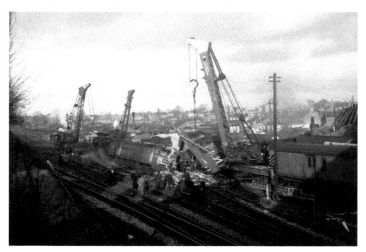

This accident happened on 11 January 1965 when a freight train crashed into Coton Hill South Signal Box, killing forty-three-year-old signalman Tom Farrington. Engine driver George Pike was also seriously injured, but fireman Ken Clorly had a miraculous escape, walking away with only a minor hand injury. Six heifers were killed in scattered cattle trucks and another had to be destroyed. Acid also began to leak from a chemical tank and among all the debris was a wagon containing explosives that meant the salvage operation had to be carried out with great care. Several large railway cranes were brought in to help in the operation.

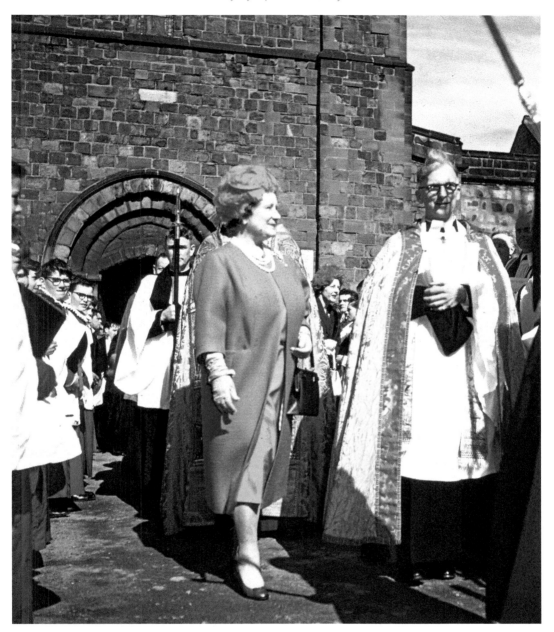

The choir boys form a guard of honour as Queen Elizabeth, the Queen Mother leaves St Mary's Church where she had just attended a service to celebrate the 1,000th anniversary of its foundation in 1963. Her Majesty flew to RAF Shawbury and before attending the service at St Mary's she dined with the mayor and invited guests at an informal luncheon of a cold salmon salad at the castle. While at the church she viewed the silver chalice from which King Charles I took communion when he visited Shrewsbury in 1642, and the Bible bearing the Royal Cipher, presented to the church by King James II in 1681. Escorting the Queen Mother out of church is the vicar of St Mary's, Preb. E. E. F. Walters.

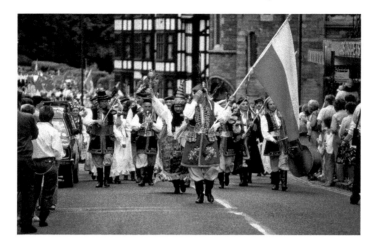

The Krakowiacy Zemi Brzeskiej dance group from Poland led the grand parade through the streets of Shrewsbury to celebrate the start of the town's seventh International Music Festival in 1985. The parade started from the castle and ended up in the Quarry where a number of performances took place. The week-long festival, which featured bands, dancers, choirs and musicians from all over the world, usually took place the week after the international Eisteddfod in Llangollen. Among the performers at this festival were the North Vancouver Youth Band from Canada, the Trinity on the Hill Youth Choir from the USA, the Children's Wind Orchestra of Great Britain and the Shropshire Schools Brass Band.

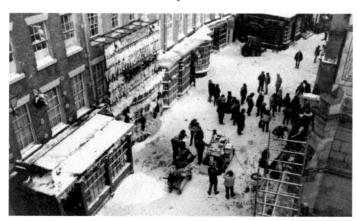

Hollywood came to Shrewsbury in March and early April 1984 when Charles Dickens's famous story of *A Christmas Carol* was filmed in the town. It starred George C. Scott as Scrooge along with Edward Woodward, Susannah York, David Warner and Frank Finley. This view was taken from the Music Hall looking towards the Gullet Passage. The market hall on the right and the buildings on the left would all have been there in the period the story is set. Only the modern shopfronts had to be altered. Work on this set started on Saturday 3 March and after working through the night was ready for filming on 4 and 5 of March. A toy shop was placed in front of Robinson's jewellery shop on the left, next to the poultry dealer with the giant turkey.

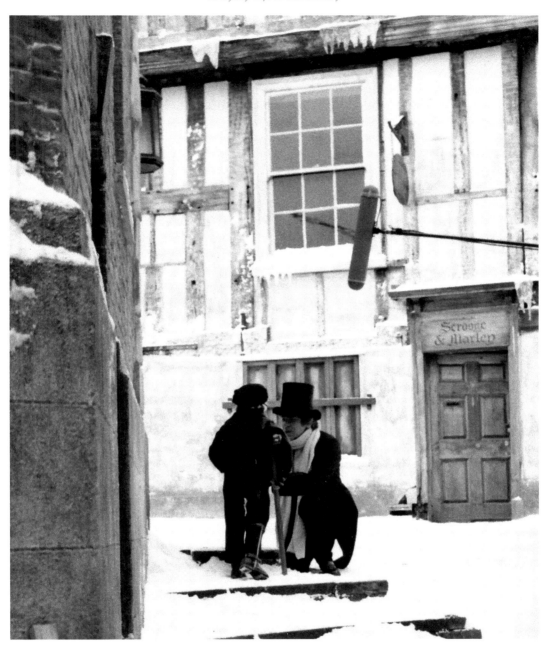

This scene was shot outside Perches' House in Windsor Place, which was used as Scrooge's counting house. Tiny Tim had been waiting in the cold for his father, Bob Cratchit, to finish work on Christmas Eve. Bob was played by David Warner, a seasoned actor who has been seen in such varied films as *Tom Jones, The Omen, S.O.S Titanic* and *Airport 79*. The ailing Tiny Tim was played by local youngster Tony Walters, who attended Prestfelde School at the time and celebrated his sixth birthday while shooting the film. The wall on the left is false and was put there to mask a public telephone box that could not easily be moved.

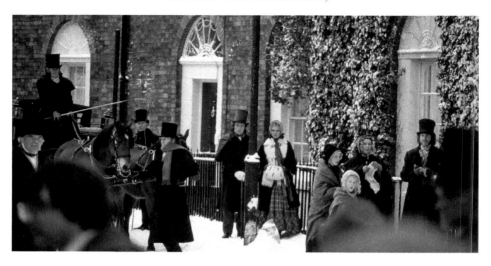

The second weekend of filming was outside The Crescent on Town Walls. Very little work was needed on this set apart from altering street lamps from electric to gas; the false snow did the rest by covering up the manholes and the double yellow lines. The end house on the terrace that had once been the Labour Exchange was used as Scrooge's nephew's house. The ground floor of the interior was also used and transformed from offices back to a Victorian hallway and living room. The first lady from the right is the well-known Shrewsbury actress Heather Game.

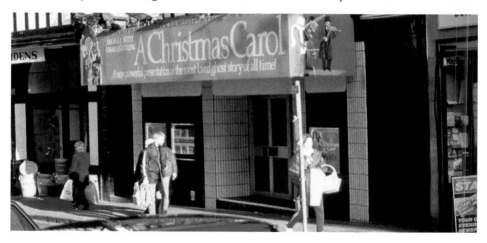

Filming finished on 10 April but many weeks of work still lay ahead at the Pinewood Studios where the hours of film shot would be cut and pieced together to make the finished product of around 100 minutes. The film, which had been shot for American television, had a royal premier attended by the Queen and Prince Philip at the Odeon in Leicester Square on 5 December 1984. Two days later it had a second premier at the Empire cinema in Mardol when a large crowd gathered to see some of the stars of the film tread the red carpet. The film was also retained at the Empire for several weeks and each night queues stretched from the cinema, down Mardol and round the corner into Smithfield Road.

After the premier at the Empire a reception was held at the Prince Rupert Hotel where the audience, who had paid £25 to see the film, could mingle with the stars. All the money raised during the evening was donated to the children's unit at the Royal Shrewsbury Hospital for a Tiny Tim playroom. Extra money was also raised at the event when a first edition of *A Christmas Carol* was put up for auction. Two of the stars who attended the premier turned up the following morning in The Square to support the Round Table Father Christmas Float. They were Edward Woodward, who portrayed the Ghost of Christmas Present, and Frank Finley, who played Marley's Ghost. They are seen in front of Father Christmas with Round Table Chairman John Hollick.

During the summer of 1984 a film crew returned to Shrewsbury to shoot scenes from *The Pickwick Papers*, another of Dickens's books, for a BBC Sunday evening serial. Scenes of an election between a Mr Slumkey and a Mr Firkin were shot in The Square and on their arrival by coach Mr Pickwick immediately joins in the chorus of 'Vote for Slumkey'. When asked by his travelling companions why he was shouting for Slumkey, he replied that there were more of his supporters there. Having a well-earned rest between scenes outside the Music Hall are Nigel Stock, who played the part of Mr Pickwick, and Philip Daniels, who played his faithful servant Sam Weller.

Another site used for *The Pickwick Papers* was this one erected outside the entrance to the Prince Rupert Hotel at the top of Butcher Row. It represented the Great White Horse coaching tavern in Ipswich. The horse had been used in another BBC production as a unicorn and if you look closely you can see where the horn between the ears has been cut away. Another set was erected for the film, just around the corner in Fish Street, and the serial was shown over twelve episodes on a Sunday evening during the autumn of 1984.

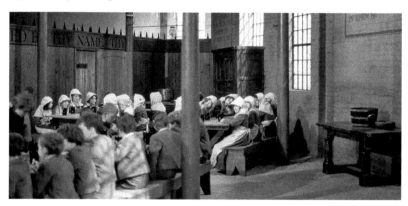

The following year a third Dickens classic was filmed in the town by the BBC for another Sunday evening serial. It was *Oliver Twist*, with scenes being shot in Shrewsbury and at other sites around the country. This scene was shot inside the old Buttermarket on Howard Street, which was being used for the inside set of the workhouse and where the famous scene of Oliver asking for more food was filmed. Oliver was played by Scott Funnell, and Mr Bumble by Godfrey James, who played the villain Harry Mowlem in *Emmerdale*. Shortly after this event the Buttermarket, which had fallen into a state of disrepair, was completely renovated as a nightclub. The market was built at the terminus of the Shrewsbury Canal in 1836 and was used later as a warehouse by the railway.

A group of actors and extras assemble outside John Wesley House in Fish Street ready to shoot another scene. The man in the dark brown clothes is Frank Middlemas, who played Mr Brownlow. He was also the last actor to play Dan Archer in the long-running radio serial *The Archers*. To the left in the lighter brown clothes is Seb Craig, who was Shrewsbury's Entertainment Officer. They are just about to chase young Oliver down Bank Passage towards the High Street. Young Oliver must have been an extremely fast runner as one second in the serial he is running down Bank Passage in Shrewsbury and the next through the streets of Lincoln where other parts of the film were shot.

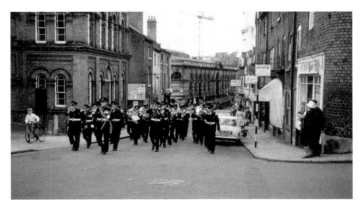

A band and troops of the King's Shropshire Light Infantry march up St John's Hill towards the Quarry on 6 June 1962 to celebrate the Battle of Bligny when the regiment won the Croix de Guerre, France's highest military honour. The honour was earned by the 4th Battalion, who made a splendid dash uphill to recover lost ground. It was reported that 'Bligny Hill was regained at the point of bayonet. A machine gun and forty prisoners being captured. The casualties were two officers (wounded) and seventy-five other ranks.' Most of the troops were boys of eighteen. The medal was presented to the 4th Battalion by Marshal Bertelot in the Quarry in June 1922. It was to be borne on their Regimental Colour. The men were also given a ribbon of the Croix de Guerre to be worn on the left-hand side of their cap.

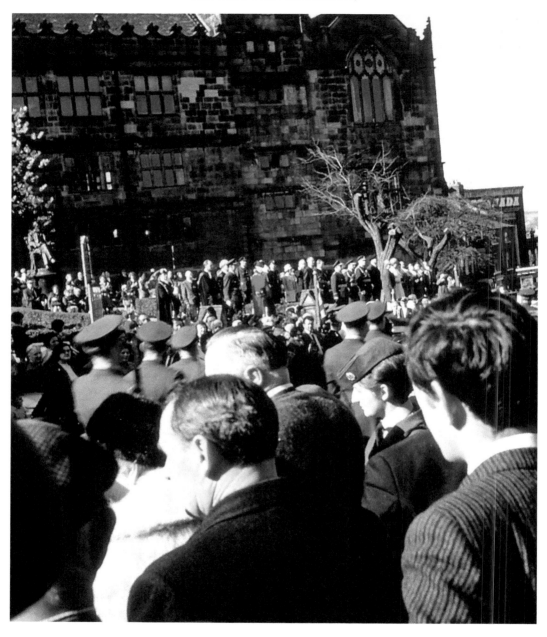

This event took place on a beautiful spring day on 28 March 1968 in what was to become known as 'The Sunshine Salute to Shawbury'. Shortly before, at a ceremony in the Council Chamber of the castle, the Mayor Alderman Pursell had granted RAF Shawbury the Freedom of the Borough. After the ceremony the mayor addressed the men from RAF Shawbury on the library steps. The band of RAF Cosford then led the parade through the streets of the town with swords drawn, bayonets fixed, colours flying and drums beating. This event, which cemented the strong bonds of friendship between Shrewsbury and RAF Shawbury, coincided with the fiftieth anniversary of the founding of the RAF.

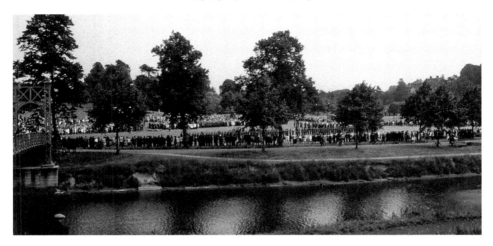

A large crowd of people gather in the Quarry and on the Porthill Bridge on the 25 June 1964 to watch Princess Mary, the Princess Royal present new colours to the 4th Battalion of the King's Shropshire Light Infantry. The Princess had been a regular visitor to Shrewsbury over many years going back to the 1930s. In the past she had visited all the hospitals in the town, opened a new wing of the Eye, Ear and Throat Hospital, the Shelton to Emstrey bypass and attended the schoolchildren's Empire Day celebrations in the Quarry. On this occasion she was kept busy as she also officially opened the new Telford Way link road and Territorial Army Centre at Sundorne.

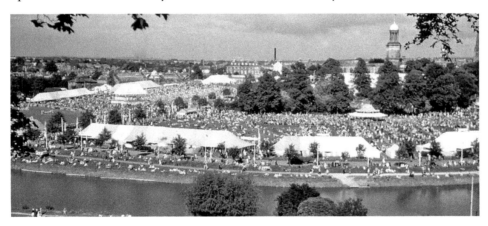

This view of Shrewsbury Flower Show was taken from Kingsland around 1960. The show is also known as 'The World's Wonder Show' and was first held in the Quarry on 29 and 30 July 1875. It was a great success, making a healthy profit of £409. The main marquee is behind the trees, where horticultural experts Harry Wheatcroft and Percy Thrower would exhibit their wares and pass on useful tips to the public. Huge crowds gather around the bandstand to hear top military bands perform throughout the day. On the left large crowds also gather around the main arena and the stage. After the large lime trees were cut down, flagpoles were erected to hang strings of coloured lights around the river walk and Central Avenue. Note the old baths just above the stage and the Victorian market clock to the right of St Chad's tower.

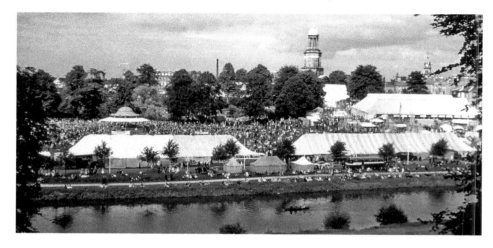

People picnic on the banks of the river and around the bandstand while being entertained by the bands. Through the trees you get a glimpse of the colour in the Dingle, the centrepiece of the Quarry that is always at its best during the August show. The large tent on the left would house the floral art displays while the one on the right was one of the catering tents. The large marquee on the right is where the amateur gardeners would show off their prize flowers, fruit and vegetables. Between the tents are the tradesmen's stalls that supplied a variety of gardening and horticultural needs. Another great attraction that happened outside the showground was the Cheap Jacks that assembled in the market for the two days of the show.

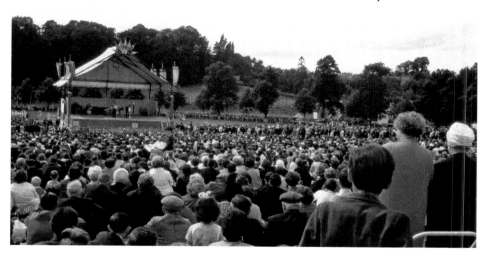

The stage show would attract huge crowds, no matter what the weather, to watch the performances of circus and music hall acts from all over the world. In the early years of the show eight hours of 'Marvellous Performances' were advertised, with a fresh act every fifteen minutes. The money was also very good as performers were paid for a full week for just two day's work. Note the curtain erected around the back of the stage, which was to stop people across the river with binoculars watching for free after the old lime trees had been removed.

This view from the stage shows a limbo dancer performing in front of a huge crowd. Acts were varied and included the Selbini Bicycle Troop, the Franz Family, Lady and Gentlemen Acrobats in Full Evening Dress, Baretto and Artell, comical French clowns, and the Three Ottos in Fun and Mischief. However by the 1960s, with the advent of television and such shows as *Sunday Night at the London Palladium*, which you could watch from the comfort of your own home, the stage's popularity waned and it was finally abandoned after nearly 100 years.

To replace the stage and to attract a younger audience, a children's area was set out on Salt's Field next to the Kingsland Bridge, where there were fairground rides and non-stop entertainment throughout the day. Top children's television stars, such as Rod Hull and Emu, the Wombles, Jon Pertwee as Dr Who and Grotbags the witch, were invited to the show. Grotbags is seen here in her tent by the side of the river signing an autograph for Vicki Trumper. Grotbags was played by Carol Lee Scott, who sadly died in July 2017.

This is Britain's Head Gardener Percy Thrower in the greenhouse at the back of the Quarry Lodge that was his home for many years. He came to Shrewsbury as parks superintendent in 1946 and served in that capacity until 1974. He gained fame from his radio and television programmes and his work on the *Blue Peter* children's show. After leaving the parks department he opened the Percy Thrower Garden Centre on the Ottley Road. He also continued to appear on BBC Television's *Gardener's World*, with the programme often being filmed at his home, The Magnolias, near Bomere Heath. He died on 18 March 1988 but his achievements have been commemorated by a bronze bust of him being placed in the Dingle.

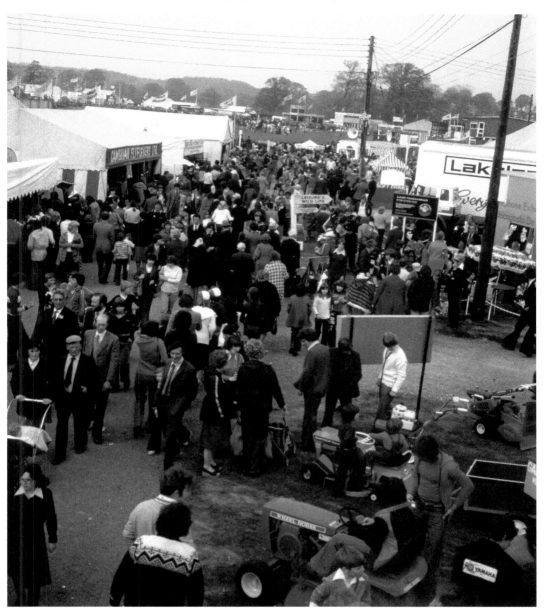

Like the Flower Show, the West-Mid provided hours of entertainment in the main arena at the top of the photograph. As well as parades of livestock there were visits by the Royal Canadian Mounted Police and the King's Troop. There were also falconry displays, dog agility trials, pageant parades, dancing diggers and horse jumping. Schools and groups like the WI were also encouraged to participate with country dancing, cooking, art and other activities. As well as the main entrance off the Berwick Road a pontoon bridge was erected in 1946 between Frankwell and the showground. It was built by the Royal Engineers on the direct orders of 'Manny' Shinwell MP. It proved such a success that the show bought their own, which was used until the early 1990s.

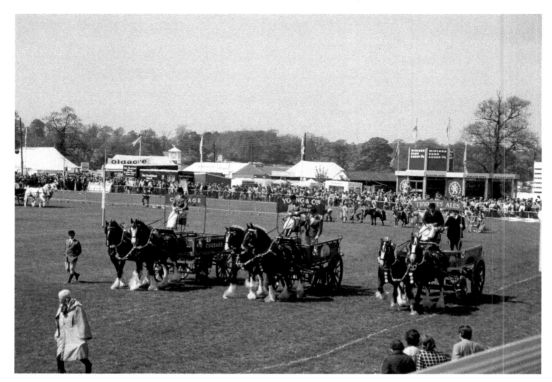

The West Midlands Agricultural Show was known locally as the 'West-Mid Show'. It was first held in the Quarry with the Shrewsbury Flower Show on 29 and 30 July 1875. The shows went their separate ways when the West-Mid moved to a permanent showground by the side of the river along Berwick Road. The show was always held around the third week in May and was very popular with the general public as well as farmers. At the centenary show in 1975 Her Majesty the Queen attended and was delighted when one of her cattle won first prize in the 'In Calf Heifer Class'. In recent years the two-day show ran into financial problems and folded; however it has been replaced by the Shropshire Show.

RAVEN MEADOWS REDEVELOPED

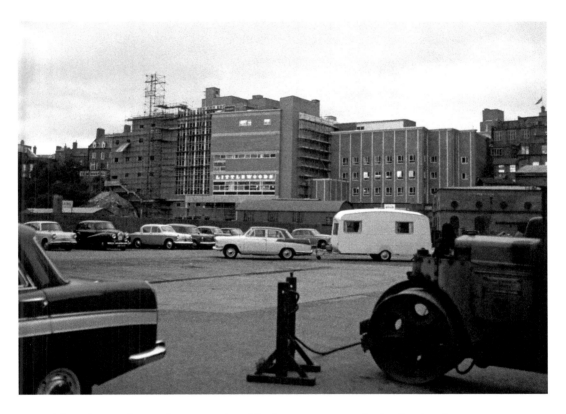

After the cattle market moved to Harlescott a great deal of redevelopment was seen in Raven Meadows and to the rear of Pride Hill and Castle Street. This view was taken in 1964 and shows the rear of Marks & Spencer on the right, Littlewoods and Woolworth's. Littlewoods was new to the town and was opened in the summer of 1964. Woolworth's store, still under construction, was built on the site of the Raven Hotel. It was opened in the October, just in time for the Christmas rush. The steps at the rear of Woolworth's would eventually be linked to a footbridge connecting the back of the stores to a new multistorey car park and the Riverside Shopping Centre.

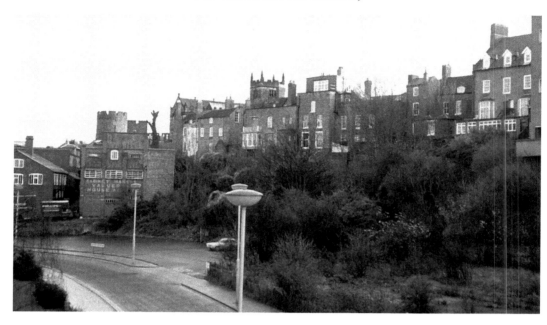

The houses are at the rear of Castle Street and in School Gardens, with the pinnacles of the library tower top centre and the castle on the left. The building below the castle is the rear of a shop on Castle Gates that was once occupied by W. H. Smout & Son, who were listed as house furnishers. It was known as Blower's Repository who were previous owners and furniture removers/storage experts. By 1972, when this photo was taken, the furnishing business had closed and the removal and storage area was occupied by Phillips' Furniture Warehouse. In 1975 it was gutted by a fire and the site is now occupied by Shropshire Records and Research Centre.

This is the bottom of the Seventy Steps Shut that led up from Raven Meadows to the top of Pride Hill. In Owen & Blakeway's history of the town it was stated that the passage had 'seventy-five broken and irregular steps'. It has also been known as Burley's Shut after a painter who had workshops at the foot of the steps around 1728 and later as the Waggon & Horses Shut from a public house near the top. The inn closed in 1883 and the passage reverted back to its former name. The wall on the left was once part of the Shrewsbury Electric Light Works. During the building of the Darwin Shopping Centre the steps were realigned and although the entrance on Pride Hill is the same, the exit in Ravens Meadows is around 50 yards to the right.

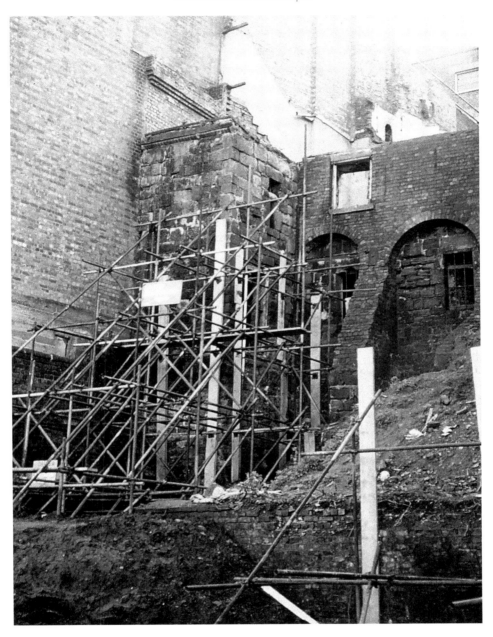

This is part of a medieval town house built on the old town wall at the rear of Pride Hill Chambers. It was approached through an archway on Pride Hill that led to buildings that were used mainly for offices. After the offices were emptied an archaeological dig took place which exposed a great deal of the town wall, a sally port, and a garderobe. In 1982 the site was converted into a McDonald's Restaurant. As a preservation order was put into place to conserve the old part of the site, the firm carefully incorporated the lower floor into a themed medieval banqueting hall. McDonalds moved out of town in 2017 and the site is now being altered.

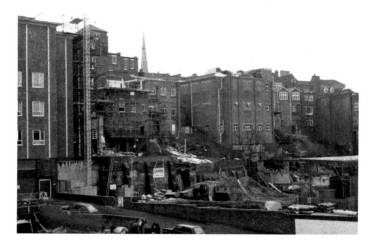

The building firm Laing are preparing the site before starting work on the building of the Darwin Centre. The building on the left is Marks & Spencer's store, while the building with the rounded windows to the right belongs to Morris's and was built in the 1920s as their 'flagship store'; it is now occupied by WHSmith. The building with the pipes running down the side is the old Woolworth's store before they moved in 1964. The shop was then taken over by Timothy White's store and later Boots before being demolished to make way for the main entrance into the shopping centre. Bottom right is part of an electrical service unit on the site of the old power station at the foot of the Seventy Steps.

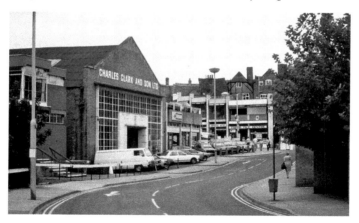

Shuker & Son had this garage on the corner of Raven Meadows and Roushill that was linked to their hardware shop on Pride Hill. They merged with Charles Clark & Sons Ltd who owned another garage in Chester Street in August 1956. The redevelopment of the area in the 1960s gave better road access from Mardol and Smithfield Road and allowed the firm to build a modern car showroom and garage. As the site was being redeveloped a leading archaeologist, P. A. Barker, excavated part of the old town wall and unearthed some interesting pieces of medieval pottery. The new building to the left is the Conservative Club that moved there from Pride Hill Chambers. The old buildings behind the Tile Centre are in Mardol.

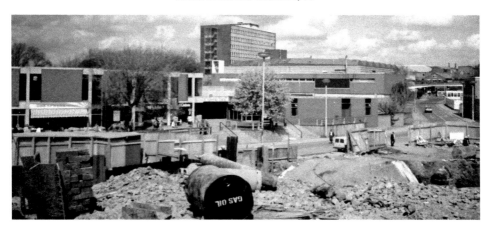

This view was taken from Roushill after the garage and showrooms were demolished. The tall building is Telephone House, which was the first building to be erected on the old cattle market site. This is the Raven Meadows entrance to the Riverside Shopping Centre, which also had another entrance on the Smithfield Road. At the top of the steps on the right was a small police station. Just below Telephone House is the top of the clock tower that was erected in the middle of the centre but was demolished when the centre was revamped in 1993. To the right is the footbridge leading from the multistorey car park to the rear of Woolworth's and Littlewoods stores.

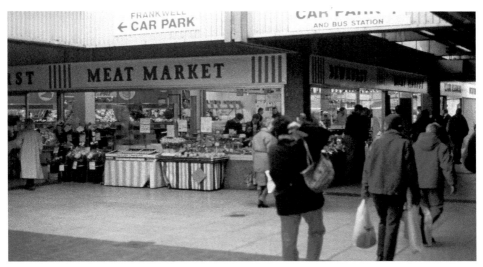

When the Riverside Shopping Centre was first envisaged in the early 1960s it was described by some councillors as the 'Whitest of white elephants'. However by 1979 and after the Frankwell footbridge had been erected, giving a direct route over the river to the centre, the complex was hailed a great success. Throughout the 1980s it had its own unique market atmosphere with dozens of shop units selling a wide range of goods which included meat, fruit and vegetables, DIY, clothing, sports equipment, frozen food, carpets and furniture. In 1993 it was given a £6 million overhaul when it became an extension of the Pride Hill Centre.

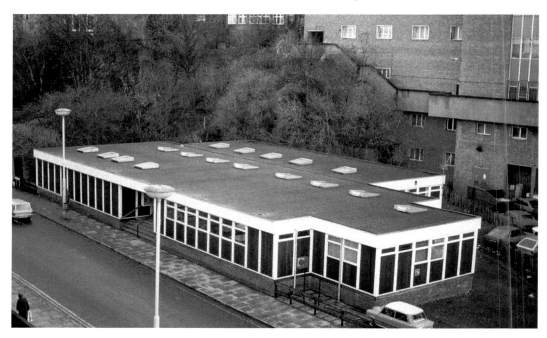

During the restoration of the library on Castle Gates the building was closed to the public and the reference and lending library moved to this temporary building in Raven Meadows in October 1976. The Local Studies library, which had been housed in the 'Top Room' of the old building, was found separate accommodation in St Mary's Church Hall, near The Parade. This building lay directly beneath Woolworth's store and the walkway to the rear, leading to the passage that brought you out into Castle Street, is clearly visible.

When plans were drawn up for the redevelopment of the cattle market site they included a bowling alley, an ice rink, a riverside restaurant and a luxury hotel, but all were dropped when work got underway. Tiffany's Nightclub did materialise, which brought Henri Quinn to Shrewsbury as an entertainment centre manager. He was responsible for bringing many top-class acts to the venue and for organising some memorable Christmas and New Year's Eve parties. The nightclub had several changes of name, which included Park Lane and the Fridge, Liberty's, Liquid and Diva, Onyx and Blu and most recently Inferno, which closed in 2017.

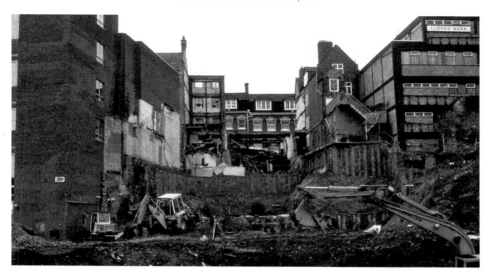

By August 1986 work was well underway in clearing the site of the new £20 million Pride Hill Centre. This view shows the buildings cleared from Pride Hill to make the main entrance into the new centre. The building on the left is Boots store, while the new building on the right is the rear of Lloyds Bank, erected in the 1960s. The buildings opposite in Pride Hill were once occupied by Maddox and then Owen Owen's departmental stores, before being broken down into smaller units. Note the old building on the right has been preserved while the frontage of an old building next to Boots has also been kept.

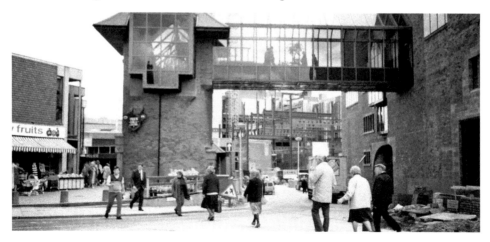

The people on the right are coming out of Roushill and heading for the new escalator that will take them up to the walkway and into the back of the Pride Hill Centre. The centre, which was developed by Hardangers Properties and their builders Tarmac Construction, was opened on 18 March 1988. Thousands of customers were anticipated over the first two days and it was expected to boost trade and help the town compete with Telford. In the background the remaining giant crane continues to work on the construction of the Darwin Centre that was opened the following year.

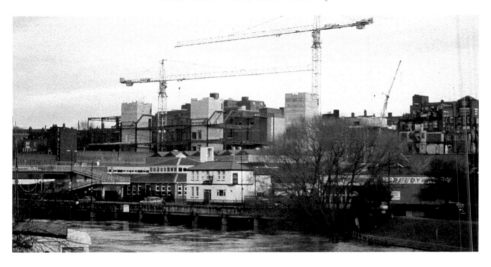

Work on both shopping centres can be seen on this view taken from the Welsh Bridge in 1987. The Darwin Centre was the largest and cost over £40 million. One of the biggest problems with both sites was the foundations. The country's biggest pile driver was used and the piles that were sunk on this site were the deepest on any construction site in the country at that time. Over a period of several months these two 129-foot cranes towered over the developments, moving heavy materials around both sites. During the Christmas period both were decorated with a Christmas tree.

A new bus station was built next to the multistorey car park as part of the Darwin Centre development plan. The new fifteen-bay station was linked by a high-tech pedestrian concourse that provided new public toilets, a waiting area, a parcel store and travel shop. Access to the shopping centre was by escalator. When the new station came into operation in October 1989 it caused traffic chaos around the town with long tailbacks especially in Castle Foregate and Ditherington. On the right is Telephone House, which was removed in 2002 and has been replaced by a Premier Inn.